A HISTORY OF

Virginia Wines

A HISTORY OF

Virginia Wines

FROM GRAPES TO GLASS

Walker Elliott Rowe

FOREWORD BY RICHARD LEAHY
COLOR PHOTOGRAPHY BY JONATHAN TIMMES

Charleston · London

THE
History
PRESS

Published by The History Press
Charleston, SC 29403
www.historypress.net

Copyright © 2009 by Walker Elliott Rowe
All rights reserved

First published 2009

Manufactured in the United States

Cover photography and design by Marshall Hudson

ISBN 978.1.59629.701.2

Library of Congress CIP data applied for.

CONTENTS

FOREWORD

As a wine journalist specializing in Virginia since 1986, it's a pleasure to read any new book on Virginia wine that is as original, well-researched, informative and enjoyable to read as this one. *A History of Virginia Wines: From Grapes to Glass* by Walker Elliott Rowe is a welcome addition to the literature that offers a fresh and insightful way of viewing Virginia wine from its origins at the start of the American experiment in Jamestown to the present.

While many regional wine books offer a boilerplate format of history followed by highlights of leading wineries as seen by copious notes in their tasting rooms, or lengthy discourses with eccentric owner/winemakers over bottles of their reserve wines, this book is written in such a way that any interested Virginia wine reader will be able to learn about the many aspects of the subject, from history to the latest in marketing trends, without being bored by too much detail. The book is organized in easy-to-digest chapters that focus briefly on a wide range of relevant topics, so the reader can learn about a subject and then move on to another without feeling weighed down with too much information.

Rowe begins the book by explaining in two different tastings how far Virginia wines have come in thirty-two years, and the rest of the book illustrates that story through the people involved and explains their mundane, everyday tasks that have made this transformation. Rowe's style is strong on interviews with leading industry members, so you hear things from their perspective, whether from winery or vineyard owners, winemakers, researchers, lobbyists or even migrant workers who are too often ignored in the story of fine wine. Rowe's own opinions, while included, stay in the background and avoid the trap of too many wine books that focus on how well the author ate and drank his way through the

wine region instead of giving the reader useful and original insights on the area. Rowe also avoids the trap of trying to rank the wineries and discuss their top wines, and instead focuses on the industry as a whole.

The cast of industry players you meet is varied and fascinating. As with other wine regions, Virginia has attracted some brilliant, dedicated and hardworking leaders, as well as its share of iconoclasts and trailblazers. You'll meet pioneers like Felicia Warburg Rogan of Oakencroft Vineyards, Gabriele Rausse and the late Archie Smith III of Meredyth Vineyards; large winery owners like Patrick Duffeler; independent grape growers like Chris Hill; energetic entrepreneurs like Chris Pearmund, with no fewer than three (!) wineries; and a variety of winemakers, the majority of whom attest to the influence of the Old World as their primary model for Virginia and how this influences Virginia wine style.

Rowe takes you behind the scenes of the Virginia wine industry, and you can visualize yourself in a winery tank room with a broken press motor and bins of fruit left to press, or working hard in a hot vineyard to save enough money to send back to relatives in Mexico, or lobbying behind the scenes in Richmond to keep the interests of farm wineries in the minds of legislators, or sitting at a table where winemakers are discussing the technical pros and cons of their wines. You learn which grape varieties grow well here and why, and in addition to the well-known viognier, chardonnay and cabernet franc, also get to know varieties that you may never have heard of that are putting Virginia on the wine world map in a new way, such as petit manseng, petit verdot, tannat, traminette and chambourcin.

This book breaks new ground in historical research as well. Most fans of Virginia wine have heard that grape growing was mandated by the Jamestown legislature in 1619, but that European viticulture failed even when Thomas Jefferson spent decades at Monticello and nearby Colle cultivating leading European (vinifera) grape varieties because the phylloxera vine louse was unknown at the time. Rowe explains in detail how Philip Carter Strother, descendant of a Virginia landowner named Charles Carter, discovered that this ancestor was documented as having successfully produced Virginia wine (specifically cited as including vinifera grapes), and after his claim was duly certified by visitors from England, he was awarded a commemorative medal by the Royal Society of London in 1762. And so we learn the fascinating missing chapter in Virginia wine history. As the Philip Carter Winery's motto explains, "Before there was Jefferson, there was Carter."

Readers who appreciate wine and want to understand its technical aspects a little, without being overwhelmed, will find this book valuable. Rowe takes a number of isolated technical subjects, like clones of grape varieties, cold stabilization, the champagne method, yeast nutrition during fermentation

and hydrogen sulfide issues, and explains them separately, in manageable size for the lay reader, while at the same time enlightening the subject and demystifying it.

Rowe also covers the marketing side of the business, from major wine tasting events to the dynamics of market pricing and the relative competitiveness of Virginia wines. Why are Virginia wines more expensive than many you'll find in the grocery store? This book explores that question well; part of the issue is people's perception that since Virginia is an "emerging" wine region, its prices should be less than say those in Napa, which is an "established" region. However, comparative tastings, scores in international wine competitions and accolades of respected critics confirm that top Virginia wines are on level with the best in the United States. So are Virginia wines overpriced or underappreciated, and what should be done about it?

Those who love Virginia and its wines, and want to learn in order to appreciate both more, will find *A History of Virginia Wines: From Grape to Glass* a rewarding and stimulating read, which I expect will leave them with more appreciation, as well as more appetite to become intimately acquainted with the subject and its incarnation (bottles of Virginia wine) than they had before they read the book.

Richard Leahy, 2009

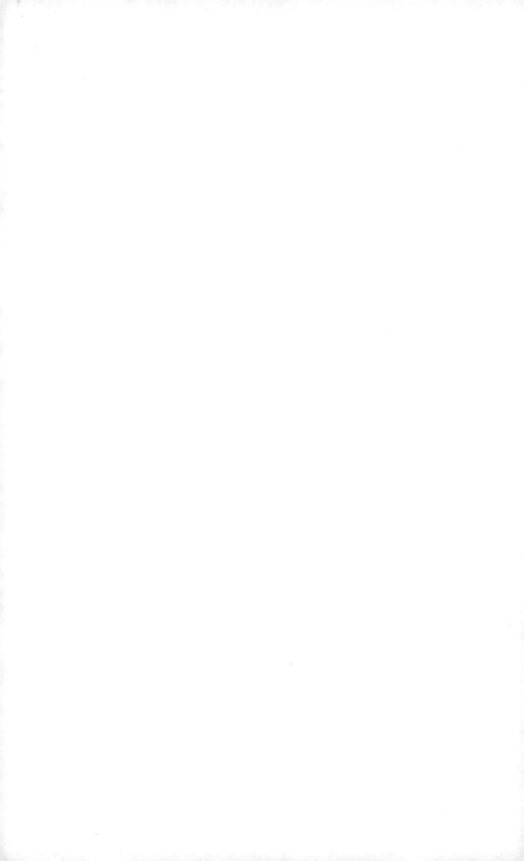

FROM BURCHARD TO BROADBENT

Hank Burchard, a writer for the *Washington Post*, wrote in 1977 of a blind tasting held at the *Post* to compare wines from two Northern Virginia wineries, Farfelu and Meredyth, with Maryland, New York and California wines. He wrote, "The best of the Virginia wines were judged to be barely drinkable, and no bargain at half the price. The worst made us gag. One taster wilted under assault and had to retire. After the ordeal was over we sat around the long table, turning bottles in our hands and trying to puzzle out what possessed their winemakers to release them for sale." The situation in Virginia is much changed today, as Virginia wines have improved many fold, as the tasting described at the end of this introduction shows. But the industry has still not achieved nirvana. This book is a tour of what is current in Virginia as well as what has transpired in the past.

In the past, Virginia had a winemaking industry. It thrived prior to Prohibition, making large quantities of wine from *vitis labrusca* grapes like concord, whose acidity and bubble gum flavor shocks rather than seduces the senses, and a *vitis aestivalis* variety called "norton," which is still planted in Virginia today and considered by some, but not all, to be a fine wine. For a time, the high-selling Virginia Dare wine was made here from scuppernong grapes grown in the Carolinas—the owner had relocated his winery to Virginia in an attempt to move out of the way of prohibitionist sentiment roiling the Carolinas. Yet contemporary grape growing on the East Coast owes its origins to New York State.

At Cornell, U.P. Hedrick, noted grape and fruit tree breeder, published several books on fruit, including *The Grapes of New York* in 1908. In it, he called the Hudson Valley of New York the "birthplace of American viticulture." New York was home to such giant wine companies as Taylor

Wine Company, which made cheap wine for winos and millions of gallons of low-quality champagne, plunk and swill. The quality of the New York wines was so bad that the dauphin of the Taylor Wine Company, Walter Taylor, struck out on his own. To return the company to its roots, he bought a vineyard called Bully Hill, originally farmed by his grandfather, and constructed a new winery, criticizing and attacking his family's business. A 2001 *Wines and Vines* magazine article reports, "He was fired from Taylor Wine Company by his uncles for criticizing wine production there. When Taylor Wine Company was sold to Coca-Cola he was forbidden to use the name 'Taylor' on his wines."

Early grape growers in New York and elsewhere had followed the advice of Philip Wagner, the editorial page editor of the *Baltimore Sun*, who in his 1945 book, *A Wine Grower's Guide*, directed eastern growers to plant French hybrid vines, which he sold from his Boordy Vineyards in Maryland. He had brought to the United States grapes like seyval, rayon d'or, baco noir and vidal blanc that had been crossbred in France and planted there when phylloxera had decimated the vineyards in Europe about the time of the American Civil War. Philip Wagner said that vinifera grapes, the Old World varieties like merlot and chardonnay, should not be planted in the East because it was too cold and there were too many diseases that would defoliate the vines and rot the fruit. In the 1940s, he was right. But then the situation changed as agricultural science progressed.

In New York, one grower, Dr. Konstantin Frank, challenged the views of Philip Wagner head on. An article in *Time* magazine says of Mr. Frank, "Moving with his family to the U.S. in 1951 he was disappointed by many of the wines that were being produced by the big New York State companies. Made basically of labrusca, many of these wines were watered, sugared and started out with as much as 25% California wine, shipped in by tank car— and legally sold as New York State wine." Dr. Frank had emigrated from Ukraine, where he had overseen a two-thousand-acre collectivist wine grape farm planted by the Soviets. Coming to New York with no money and no English, he was reduced to hoeing blueberry bushes at Cornell University when he approached Charles Fournier of the Gold Seal wine company about the possibility of growing vinifera wine grapes there. Dr. Frank said that if vinifera grape vines could survive the negative-forty-degree Fahrenheit cold of the Ukraine—where he told *Time* magazine, "If you make spit, it will freeze before it hits ground"—then they could survive the relatively mild New York winters. It had worked in the Ukraine because Dr. Frank invented a plow called the "grape hoe" to bury the vine in winter, thus protecting it from the cold. Konstantin Frank's plantings were successful, and by the 1960s, he had built his own winery, called the Vinifera Wine Cellars, in New York.

From Burchard to Broadbent

In 1984, Harper & Row published a memoir by Mark Miller, *Wine: A Gentleman's Game*, on the first farm winery in New York. Mr. Miller had been an illustrator for New York and Boston magazines for many years. He bought a vineyard in 1957 along the Hudson River near Newburg, New York, and then moved his family to Burgundy so that he could make illustrations for European magazines when photographs replaced drawings in U.S. magazines. But his allure for growing grapes only grew stronger living in France and for several years amongst the medieval caves of the French *vignerons*. His book is an entertaining memoir and, of course, is handsomely illustrated.

Mr. Miller talks of his David and Goliath battles of the small New York farm wineries against the big wineries of the Taylor Wine Company, Canandaigua Wine Company (twelve million gallons), Royal Wine Company and Barry Wine Company, which were irritated by and generally not supportive of the gadfly small winemakers. But Mr. Miller pressed ahead, planting the French hybrids baco noir and Marcel Foch and convincing the esteemed New York wine shops Sherry-Lehman's and Morrell's to carry his wine. He even enlisted the actor Burgess Meredith, the gravel-voiced boxing coach in the film *Rocky*, to help promote Hudson Valley Wines. Finally, following in the footsteps of Dr. Frank, Mr. Miller planted chardonnay, cabernet sauvignon and pinot noir, ripping out the hybrids Delaware, chancellor, chelois and de chaunac.

Dr. Frank's influence spilled over into Virginia as well, where he found an enthusiastic supporter in Treville Lawrence, who lived in the Plains. Treville planted a hobby vineyard of vinifera and started an organization called the Vinifera Wine Growers Association (VWGA) after producing his first vinifera wine in 1970. The VWGA published the *Vinifera Wine Growers Journal*, which was an amalgamation of technical articles on viticulture and enology from other magazines; it also included lots of original reporting and research. At first the journal set as its goal: "The VWGJ is dedicated to expanding technology in the premium wine growing field, by promoting greater scientific study and experimentation to find means of cultivating the best vines that will make the highest quality table wines through the United States, whether they be Vinifera, French Hybrids, or some yet to be perfected variety." But then Treville got caught up in the argument between Dr. Frank and Philip Wagner. Dr. Frank wrote,

I must ask these promoters of the French Hybrids do they not know that French Hybrids are dangerous to the grape industry? Do they not know that because of very low quality and the problematic effect to health the French hybrids are prohibited in all countries of Europe? How can we present the French hybrids

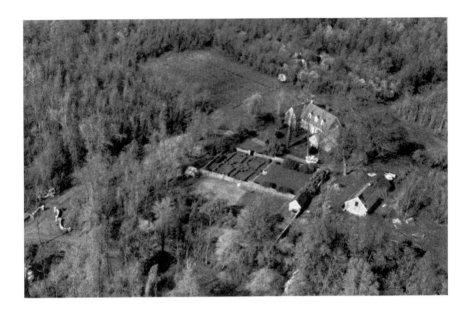

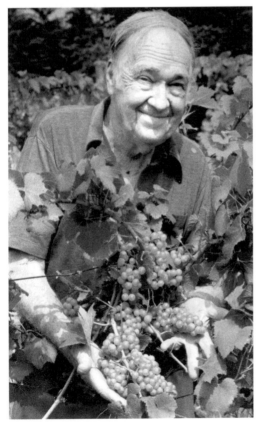

Above: Treville Lawrence's Highbury, Plains, Virginia, spring 1984. If Lawrence is the grandfather of the twentieth-century Virginia premium wine industry, Highbury is its cradle. Established in 1968 with its wine cellar and experimental vineyard, here Lawrence demonstrated for the next thirty years that varietal wine grapes necessary for premium wines could be grown in Virginia, with wine and vine seminars (1972); Vinifera Wine Growers Association and its journal (1973); wine festivals (1976); tastings and competitions with trophies; and numerous newspaper and magazine interviews. A steady stream of visitors heard Lawrence's message that anything less than premium was hamburger. *Courtesy of Robert de T. Lawrence IV.*

Left: Treville Lawrence shows off chardonnay grapes in his vineyard at Highbury, Plains, Virginia; these are the Burgundy grapes from which French chablis is made. *Courtesy of* Fauquier Times-Democrat, *1990, and Robert de T. Lawrence IV.*

to the American public, to the most prosperous people of the world, if they are discarded as not good enough for the poor French, Italian, even for poor Russian peasants?

He was referring to laws in Europe, where politically powerful farmers had been able to ban the cultivation of hybrid grapes. Caught up in the vitriol, by 1978 Treville struck the word "French Hybrids" from the mission statement. Treville Lawrence was quoted in *Time* magazine saying, "The key to quality is vinifera. There is no other way to make a good wine. Other wines are simply hamburger wines." Of course, by this time hyperbole had given way to outright hostility.

Move ahead thirty-plus years, and we are in a convention center in Richmond, where Bartholomew Broadbent is conducting a blind tasting of Virginia wines compared to wines from around the world. Bartholomew, who has just moved to Richmond and runs a San Francisco–based wine import business, is best known as the son of Michael Broadbent, the British author of dozens of wine books and head of wine sales at Christie's Wine Auction. Of course, the son is not the father, but it is obvious to those in attendance that Bartholomew has an experienced palate, and one would presume that he gained a lot studying at his father's side as he tasted the best wines of France and from around the world.

The tasting is held at the Virginia Wine Expo to coincide with the Governor's Wine Cup competition. Bartholomew says, "My idea was to show how good Virginia wines are in comparison to some of the best wines in the word." All of the wines are either Virginia wines or imported wines. There are none from California. Richard Leahy, who lives in Charlottesville and writes for *Vineyard & Winery Management*, helped Bartholomew pick the Virginia wines.

The first two wines are sauvignon blanc. The Virginia wine is the Linden Avenius 2007 and the import is the Spy Valley 2008 Sauvignon Blanc from New Zealand. Broadbent says, "The New Zealand one has more acid but the Virginia one has more complexity and fruit. Considering that New Zealand is considered to be the top wine-producing country for sauvignon blanc—I think it's overtaken France—I think this is an extremely good wine from Linden."

The next two wines are riesling. Of the Virginia DeChiel Reserve 2006 from Rockbridge, Broadbent says that it has more gewürztraminer characteristics. He says it has "creamy good texture, attractive nose good length," while the Louis Guntrum riesling Spätlese 2006 from Germany has "a touch more sweetness." He adds, "Clearly the Virginia riesling stands on its own." Broadbent says that he chose the German wine because it is roughly the same price as the Virginia one.

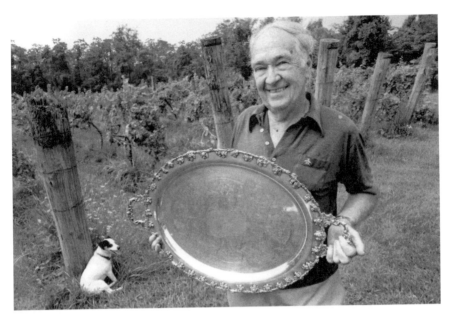

Treville Lawrence, in front of his vineyard at Highbury, holds the Productivity Tray, one of three trophies to be awarded at the Fifteenth Annual Wine Festival at Swedenburg Winery near Middleburg, Virginia. His dog Piquette guards the vineyard. The dog's name is from the French name for the cheap wine made from grape pressings after the good wine has been drained. *Courtesy of* Fauquier Times-Democrat, *1990, and Robert deT. Lawrence IV.*

Someone in the audience complains that the wines are not cold. Broadbent replies, "All wines are better colder if they don't have enough quality to be served at room temperature. If you want to taste a white wine and see all of its faults, you need to taste it at room temperature."

Of the next two, he says, "Neither is better than the other; they are just different." Of the imported cabernet franc from South Africa, the Warwick Estate Cabernet Franc 2006, he says it is "extremely good. Very pure. Perfect for putting in a tasting to show what this varietal is like." But he is clearly more pleased with the Virginia wine, the Michael Shaps Cab Franc 2007, saying, "It's got perhaps more character, less pure varietal, but it has more character, more vegetal swampy characters, and I say that in a positive way; it is more interesting."

Of the next two wines, Broadbent is talking to audience member John Higgs, the owner of the Virginia winery Barren Ridge, explaining that the $75 Quinta do Castro Touriga Nacional 2006 is "considered the top touriga nacional in the world." He says that this one was ranked number three by the 2008 Wine Spectator top Wines of the World ranking. "So when I tasted your Barren Ridge [2007, $18], I was blown away by the quality." He then

adds, "I would highly encourage Virginia to look seriously at this grape variety. You're going to possibly compete with Portugal."

It is unfortunate that now these touriga nacional vines have been ripped from the ground. Dennis and Sharon Horton of Horton Vineyards planted these vines at what is now called Honah Lee Farm Vineyard. The Hortons were evicted from the property by the owners, Wayne and Vera Preddy. Vera Preddy says that the Hortons walked away from a $1 million vineyard because "we could not get them to give us a lease." The Hortons sued and lost; Sharon Horton says that the judge slept through part of the proceedings as various expert witnesses documented the improvements that had been made, including installation of a $350,000 irrigation system. Vera says that she replaced twenty acres of touriga nacional and another variety, tinta cao, with the classic Bordeaux varieties because there is no market for the former varieties and they fall apart in late season rains. She said touriga is "an unknown grape that not everyone wants."

Of the next Virginia wine, the Barboursville 2001 Octagon ($40), Broadbent explains, "This is the wine that opened my eyes to Virginia." He says that he and his father had come to Virginia for a dinner and had visited Barboursville, Veritas and others. Upon his return to the UK, Michael Broadbent, the father, wrote about Barboursville in *Decanter* magazine. The Barboursville wine is paired with a South African Warwick Estate Reserve 2001 called Trilogy outside of South Africa, which was ranked number forty-six in the *Wine Spectator*'s 2008 Top 100 at a Glance. He does not offer judgment, saying, "They're both great wines." You can see that the Virginia wine is holding up better over time, as the South African one has begun to turn brown. Broadbent, in the way his father might write, says that he would tell people to drink this one now and not hold onto it any longer.

Of the next two wines, Broadbent is again not judgmental, especially since each of these two wines is different from the other. He simply says, "The two are extremely good wines." The import is a Chateau Giraud 2005 Sauternes ($57), which was ranked number four by the same *Wine Spectator* listing. Yet the audience votes overwhelming for the Veritas Kenmar traminette dessert wine ($35).

The audience is composed half of people in the trade and half of people with nothing better to do than drink wine at four o'clock in the afternoon. A couple asks what food should go with what wine, and one asks how to spell "touriga." Clearly, the significance of this tasting is lost on those souls, but industry insiders know what it means to have a Broadbent sanction Virginia wines in this way.

This tasting aside, all is not roses. Some in the Virginia wine industry wonder why the industry has not yet achieved the notoriety of New York,

New Zealand and other emerging wine-growing regions, and with it following from the *New York Times*, *Wine Spectator* and other critics. Industry outsiders are free with their criticism of the status quo—no quality standards, no certification that only Virginia-grown fruit goes into the bottle, infighting with the wineries and vineyard associations—but as industry insiders, they are not able to go on the record in stating what is wrong in the Dominion State. So for a blunt assessment from a noted expert, we turn to wine critic Dan Berger, who wrote the following in May 2008 in his "Vintage Experiences" newsletter:

> *Virginia's wines would be far more respected if state legislators got behind them. But it appears they are intentionally ignorant of how good Virginia wines really are. Moreover, local wine industry leaders have failed to make a strong case for their wines. Indeed, internal feuding among some wineries has left the state's wineries association far less effective than it could be; some critics say it is in disarray. As such it has failed to find the crucial funding that it could use to create campaigns to elevate the image of the state's top wines. More than anything else, Virginia needs a wine czar who isn't connected to any one of the state's sub-regions—a person not unlike New York's energetic Jim Trezise.*
>
> *It also needs state funding so the industry may coordinate campaigns to focus attention on quality and thus help elevate prices to where they ought to be. The wine industry should coordinate with tourism boards and charity fund-raisers to gain ink and speak about the great strides in quality seen over the last few years. In recent years, the state's legislature has actually done much to harm the state's largely family-run wine industry. Many politicians have happily accepted emoluments from alcoholic beverage wholesalers, then have written laws that make it even harder for wineries to be able to market their wines. Chats I've had with wine industry leaders over the last four years lead me to believe the state doesn't view Virginia wines as the state resource it really is. Its failure to crack 90 in the glossy magazines may be a cause. Still, many other wine regions do not have the blessing of the number anointers, yet still have created a buzz about their wines. It has been a quarter century since Washington created a state wine commission and its wines are now widely seen as superb. Virginia is squandering a great resource.*

Dan does not live in Virginia, but Richard Leahy does. Here is what Richard Leahy has to say in response to what Dan Berger wrote:

> *While I agree that Berger has some points about state politics and the industry, it's wrong to imply that VA wine marketing is languishing without state help. I want to point out a few examples.*

Last September, the VA Wine Marketing Office (a private firm operating on a contract basis, instead of being within the bureaucracy of VDACS) wanted to publicize the 20th anniversary of VA Wine Month in October. I worked with Annette Boyd by suggesting a 20-year retrospective tasting; the "reserve" wines older than 2001 were available to credentialed members of the media (including Dave McIntyre and Bartholomew Broadbent), and got some valuable profile in the media as well as giving legitimacy to Virginia as a region that can produce wines that last 20 years. The younger wines were served to a trade audience at the Capitol in Richmond, at which both former Governor Gerry Baliles and current Governor Tim Kaine presided, both affirming how important the industry is to the state and state agriculture. This was probably the most successful and high-level promotion of VA wines in Richmond. Dr. Zoecklein and I screened the wines and eliminated questionable ones.

Two years ago, the Virginia Wine Experience in London, acting without any state support, brought 64 (pre-screened) VA wines to a trade tasting at which Steven Spurrier, Hugh Johnson, Stephen Brook and others attended, and the reception was very positive. Subsequently (last September and again at the London Wine & Spirits Fair next month), Christopher Parker of New Horizon Wines continued the promotion of VA wines in London, and has established sales in the U.K. as well as continued positive reception from key British industry members like Spurrier.

All of these initiatives (except the Richmond 20th anniversary promotion) took place outside state channels, so just because official channels aren't producing great results doesn't mean they aren't happening through other channels.

I should also point out that Virginia wines have won double gold medals in the International Eastern Wine Competition several times. Last year for example Jefferson Vineyards won double golds for pinot gris and viognier, also the best of those varietals in the competition which had 2,200 entries. Previously Valhalla's 1998 Götterdaämmerung, Kluge Estate's New World Red 2001 and Barboursville's Octagon 2001 also won double gold medals, so the validation is there on an international level.

As for other praise or criticism, we will let the persons interviewed in this book speak for themselves. The opinions are as varied as the terrain.

Virginia Wine Pioneers

One longtime Virginia grape grower quips that fifteen years ago, the Virginia Wine of the Month Club was simply a mechanism to distribute bad wine. But the situation in Virginia is much changed today. Virginia white wines, in particular the viognier varietal, have beaten national and international competition at least three times in head-to-head contests. And Virginia red wines, while not brandishing the same success, have won some accolades from noted wine writers and a wide following along the various wine routes with the local buying public. But only thirty years ago, no one in Virginia was even producing fine wines on a commercial scale.

When the English settlers first came to Virginia, just over four hundred years ago, they were thrilled to find so many wild grapes. But they were soon disappointed to find that these native grapes made foul wine more suitable for winos than wine enthusiasts. The American varieties—except for the Virginia-bred variety norton—and even some of their modern derivatives have an unpleasant bubble gum or foxy flavor that the French call "goût de renard." So the colonists imported and planted European wine grapes—the so-called "vinifera" varieties like merlot, chardonnay, cabernet sauvignon and so forth. But these vines could not survive the bitter winters and lost their leaves and rotted their fruit in the steamy summers to maladies not found at that time in Europe.

In the early days of the republic, the most well-known winemaker and grape grower was President Thomas Jefferson, who of course lived in Virginia. The president lavished a good portion of his civil service salary on imported wines from Bordeaux. Jefferson had learned to appreciate French wines while serving as ambassador to France. Being a farmer, he hoped that French grapes could be grown in Virginia, so he imported from Italy a grape

Left: This Boars Head Inn newsletter pictures Doug Flemer (Ingleside), Lucie Morton (viticulturist), Jacques Recht (Ingleside), John Rogan (owner, Boars Head Inn and Oakencroft Vineyards), Al Weed (Mountain Cove), Joachim Hollerith (Prince Michel), Bruce Zoecklein (Virginia Tech), Karim Salehlah (Oasis Vineyards), Lou Ann Whitten (VDACS) and Bill Worral (Piedmont Vineyards). *Courtesy of Pat Reeder, Burnley Vineyards.*

Below: Treville Lawrence stands in front of his "Virginia wine library" in his wine cellar at Highbury. He is holding bottle #85 of Monticello Gardening White Table Wine (1988), the first vintage made by Gabriele Rausse from the restored vineyard at Monticello since Thomas Jefferson's time. *Courtesy of Fauquier Times-Democrat, 1990, and Robert de T. Lawrence IV.*

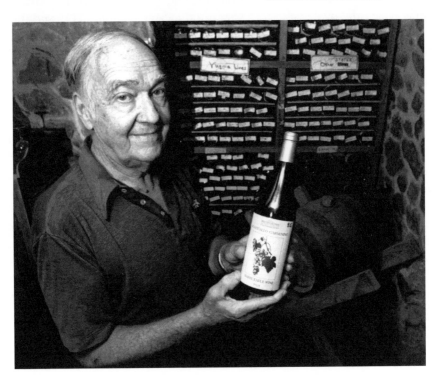

grower named Philip Mazzei and some thirty assistants to plant a vineyard at Jefferson's Monticello estate. After some years of effort, Jefferson's vines shriveled up and died; his dream to produce his own claret withered like so many raisins. It is doubtful that the Monticello estate produced even one bottle of wine, except from native grapes like the muscadine.

Today, the situation at Monticello and across the Dominion is more in line with Jefferson's vision. Because of the pioneering work done by the winemakers and grape growers profiled in this chapter, wineries have learned to grow French and Italian grapes here. Vineyards are sprouting up in Virginia like so many mushrooms after a spring rain. Where the Italian Philip Mazzei left off some two hundred years ago, two other Italians stepped into the picture in the mid-1970s, thus making possible the success that the wineries in Virginia enjoy today.

PIEDMONT

Gabriele Rausse, the grape grower who planted the first vineyards at Barboursville, concedes that Piedmont Vineyards was the first commercial vinifera vineyard in Virginia. In 1978, Piedmont produced seven bottles of wine, which the owner sold to a wine shop in Washington, D.C., and then repurchased all of it for her own cellar. For that agricultural feat, she was recognized by the governor and the Commissioner of Agriculture. That same year, Barboursville produced one thousand bottles of vine. But Gabriele says that they didn't sell it; they drank it.

The founder of Piedmont Vineyards, Elizabeth Furness, is long dead. She gave an interview to the *Washington Woman* magazine in 1984, at age eighty-six. The magazine writes, "The matriarch of Piedmont, Elizabeth Furness, turned her dairy farm into a vineyard at age seventy-five. Though she had no background for it, just the memory of what she had seen as a young girl living in France." Peering out from the pages of the magazine, Elizabeth looks resplendent with her necklace of pearls and lace dress, sitting in a wicker chair in a garden of impatiens. Her wrinkled old skin appears dignified, not weathered.

As they later told Gabriele (see the chapter "The Italians"), Elizabeth said that Virginia Tech told her it was impossible to grow vinifera wine grapes in Virginia. She told the *Washington Woman* magazine, "They objected strenuously. Told me it couldn't be done. No one could do it because Jefferson couldn't do it. That was 200 years ago. In his [Jefferson's] time they didn't spray."

The farm and vineyard manager at Piedmont at that time was Jimmy Cockerell, whose father had also managed the farm until just prior to World

Piedmont Vineyards poster.
Author's collection.

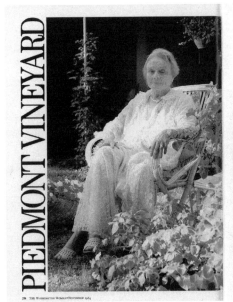

Article on Piedmont Vineyards from *Washington Woman* magazine, 1984. Washington Woman *magazine.*

War II, when the recently divorced Elizabeth Furness moved there from Chicago, having bought the sprawling property for $40,000. Jimmy and Elizabeth took courses together to learn about growing grapes, and they planted the vineyard in 1973. He said, "I am a horseman. I figure it's better to have wine growing here than them damn nuisance cows, which ain't worth the aggravation. The only reason they bought the cows in the first place was to keep my daddy out of the war." Of the early postwar years, he says, "Back then it didn't look like it does now. There was no running water in the main house. Just a spigot on the porch and chicken pens and turkey pens everywhere."

Elizabeth and Jimmy ordered chardonnay, semillon and seyval vines from California. Jimmy planted them as Elizabeth followed him around the vineyard in a folding chair, having by this time suffered two heart attacks. The stubborn Elizabeth insisted that the vines be planted as they arrived: wrapped in plastic. Later she changed her mind, and Jimmy had to dig all the vines up and replant them, this time sans plastic. Giving the vineyard advice was G. Hamilton Mowbray, who owned Mowbray Wine Cellars in Maryland. Mowbray was a legendary grower of French hybrid vines, having been awarded the Merite Agricole award from the French government.

Piedmont produced its first wine in 1977: sixty-four gallons. The next year, it produced seven hundred gallons when Elizabeth learned that the nearby Meredyth Vineyards, which had been planting hybrid vines, was planning to sell vinifera. So she rushed out and bought some bottles of her own wine just so she could say that she had been first in vinifera. In 1979, Piedmont's chardonnay and semillon sold for $5.99 and its seyval for $4.99.

In 1982, Elizabeth's daughter, the late Elizabeth "Sis" Worral, joined the vineyard business. Sis had grown up on the farm and had been one of the very few female test pilots during World War II. Her son Bill also worked at the vineyard. Today, Bill lives on a farm in Fauquier County, the family having sold the vineyard some years ago to its current owners.

MEREDYTH

NOTE: *Archie Smith III passed away in January 2009, after the interview on which this section is based.*

On a winding lane between the Plains and Middleburg in a cabin rented from a family friend, Archie Smith smokes an endless string of cigarettes and talks about the early days of the Virginia wineries. His legs are wrapped in a blanket, and he has surrounded himself with books on philosophy and

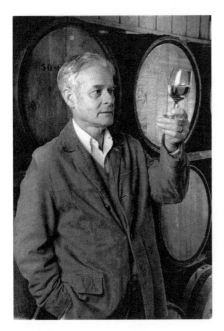

Archie M. Smith Jr., founder of Meredyth Vineyards, appreciates the color and clarity of one of the vineyard's earliest vintages of seyval blanc. *Courtesy of Susan Smith, Meredyth Vineyards.*

memorabilia of the Meredyth winery. On one wall is a 1976 White House menu listing the Meredyth French hybrid seyval.

The late Archie Smith III tells how he and a Warrenton viticulturist named Lucie Morton met Gabriele Rausse, who was working at Barboursville. He says that he and Lucie drove down to Barboursville and that Gabriele "didn't speak a word of English. Lucie Morton and I, as a matter of fact, went down to see him. There was nothing there [at Barboursville] yet. He cooked up spaghetti carmineri and we proceeded to drink far too much grappa."

At one time, Meredyth Vineyards was a large winery in Middleburg that had some fifty acres of grapes, which is a lot for a Virginia winery. Today, it is closed, its heirs having decided to discontinue the business. One of its red wines was labeled simply "Burgundy," which today of course means nothing, since only the French are allowed to use that copyrighted name. Robert Treville Lawrence IV got vinifera vines from Konstantin Frank in 1972 and gave them to his cousin, Archie Smith Jr. Bob roomed with Archie Smith III at UVA for three years.

At first glance, Archie does not look like a winemaker. His hair has the unkempt look of a scholar. He appears shrunken sitting in a low chair and wrapped in a blanket. He looks to be fading away from ill health. His sister, who lives only a couple miles away, brings him food each day.

Archie went to UVA and then debated whether to go to medical school or to Oxford to study philosophy. He chose Oxford and stayed an incredible eleven years, earning three postgraduate degrees. He produces one of the books that he wrote when he was at Oxford for the visiting journalist. Its typewritten pages are filled with the cryptic notations of deductive logic.

Archie explains that he and his parents first planted vines in 1972. Most of what they planted were hybrid vines. When Archie's parents died, the siblings disagreed over what to do with the winery. He says, "My sister and my brother just wanted to cash out and weren't willing to spend any more money maintaining the vineyards."

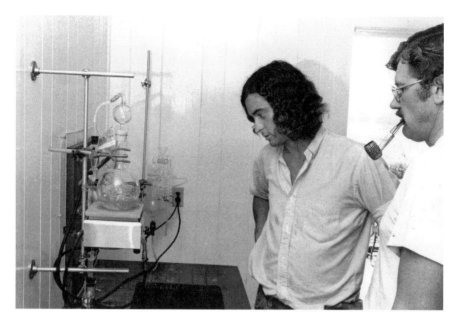

Winemakers Archie M. Smith III of Meredyth Vineyards and Richard P. Vine, winemaker of Warner Vineyards at the time, observe a laboratory test in the winery of Meredyth during the mid-1970s. *Courtesy of Susan Smith, Meredyth Vineyards.*

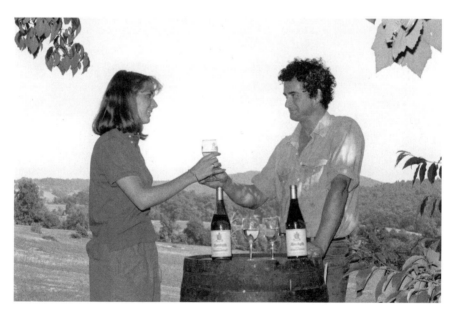

Winemaker Archie M. Smith III with Ann Schlusemeyer at Meredyth Vineyards, serving Meredyth 1983 Chardonnay, winner of a gold medal and the Virginia Governor's Cup awarded at the Virginia Wineries Association festival held July 20, 1985, in Culpeper. *Courtesy of Susan Smith, Meredyth Vineyards.*

Mike Heny is the winemaker at Horton Vineyards. He came to Meredyth in 1991 to work as a cellar rat and assistant winemaker. He says that at that time Archie had

> *the last glimmer of what had been amazing brilliance and ability and wit all wrapped together.* [He was the] *romantic image of the gentleman farmer and scholar all rolled into one. Archie had planted and maintained those fifty acres of vineyards for twenty-five or thirty years. He worked through hybrids like baco noir that no one has heard of anymore, that early '70s hybrid era, kind of like Horton has done in this era. I remember there was one really long row of cabernet franc that was planted in the '80s. He had gone to France and brought back cuttings. They kind of tried it all in that era; there were some successes and other failures. This business has borne out a lot of brilliant people.*

BURNLEY

Left to right: John Urbanski, unknown, unknown, unknown, Jim Law (Linden Vineyards), Peggy Law (Linden Vineyards), Lou Ann Ladin, Al Weed (Mountain Cove), K.T. Martin, Clair Reeder (Burnley Vineyards), Pat Reeder (Burnley Vineyards), J. Carlton Courter, Mason Carbaugh (commissioner of agriculture). *Seated:* Governor Chuck Robb. *Courtesy of Pat Reeder, Burnley Vineyards.*

Another early winery in Virginia was Burnley Vineyards, which was planted not far from Barboursville in 1977. Colonel C.J. Reeder and his wife Pat founded the winery, and their children run it today. C.J. said, "We never thought we would not have a Meredyth." Pat says that in the early days, the experts in the field who were teaching aspiring grape growers and winemakers were always the same people: Archie Smith, Lucie Morton, Doug Flemer (Ingleside Vineyards) and Gabriele Rausse. Pat says, "In those days they were the leading lights of grape plantings and growing grapes in Virginia." She adds, "Gabriele is one of the reasons we have so many wineries in this area."

Recalling those difficult early days, she says, "The U.S. Department of Agriculture kept saying you could not grow vinifera grapes in Virginia." Virginia Tech also told them that it was too cold to grow vinifera. (Today, of course, Virginia Tech fairly leads the industry, having hired two prominent scientists, Dr. Bruce Zoecklein and Dr. Tony Wolf, to mentor the young industry.) Instead, they listened to Konstantin Frank in New York and Treville Lawrence in Middleburg, who was writing his magazine *Vinifera Wine Growers Journal*.

Shenandoah Vineyards

The upper part of Virginia is divided into two sections—the upscale suburbs of Northern Virginia and Charlottesville and the rural areas where less affluent, rural people live. The dividing line in this region is the Appalachian Mountains and the Shenandoah Valley. To the east lie polo ponies, farmland selling for $14,000 per acre and up and well-funded wineries with their well-heeled patrons.

In the minds of city dwellers, the Shenandoah Valley is miles apart culturally from, say, Fairfax County. They envision a landscape where people pick apples, keep bees, sell honey from roadside stands and live in mobile and modular homes. Of course, this is not entirely true, but you can state with authority that this is not entirely false.

Standing in the middle of this rolling vista is a sophisticated woman named Emma Randel with intelligent, sparkling eyes. She and her late husband Jim—who was vice-president in charge of PR at New Jersey's largest electric company—started one of the first wineries in Virginia, and certainly the first in the Shenandoah Valley.

Emma points out that her winery is well situated right off Interstate 81. Heavily laden trucks zoom down the steep hills and then climb slowly back up the other side as cars full of travelers pass by on their way to Florida,

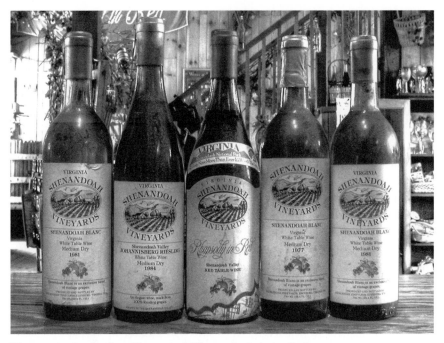

Vintage wine bottles from Shenandoah Vineyards. *Author's collection.*

Carolina or wherever. It is this tourist traffic that keeps a steady stream of customers passing through Emma's tasting room, where she sells 93 percent of her five-thousand-case annual production on-site.

That Shenandoah Vineyards caters to a less sophisticated palate than some of the Bordeaux- and Burgundy-variety wineries elsewhere is evident if you look at the winery's offerings. The wines here include the usual chardonnay and cabernet franc wines found in Virginia but include some sweeter wines as well, and of course hybrid grapes. Asked about that, Emma says, "We have a different philosophy. Our philosophy is to have a wine for every palate. How are you going to get a wine drinker to appreciate a dry heavy oak wine unless they start with something pleasant to them?" Emma's own knowledge and preference are quite sophisticated, but she enjoys the sweet stuff too. She and others in her tasting room pour it over peaches and have it for breakfast.

Emma's family is from Virginia. Her husband Jim had a severe heart attack in 1974, and that obviously jolted him out of corporate complacency and caused him to reflect on his situation. Emma brought her weakened husband down to Shenandoah, where her teetotalling family showed him a copy of *Commonwealth Magazine*, in which there was an article about growing wine grapes in Virginia. So they sought out Treville Lawrence, a Middleburg

resident who was widely known as the first person in Virginia to promote planting vinifera wine grapes in place of the hybrids. But his skills as a farmer might have exceeded his winemaking ability. Emma says, "We went and tasted some of his very cloudy wine."

Emma and her husband planted their vineyard in 1976. Back then, you could count the number of Virginia wineries on one hand. She says of her pioneering spirit, "People thought we were crazy." They rang up Virginia Tech for advice and were told, "You don't plant wine grapes in Virginia." So she and her husband turned their attention to Pennsylvania and New York, where they found seminars and other wineries as models they could follow.

Like every other commercial winery in Virginia at that time—with the exception of Barboursville—Shenandoah Vineyards started off planting hybrid grapes like DeChaunac, chambourcin, vidal blanc, seyval blanc and others. This list sounds influenced by the preaching of Philip Wagner, the former *Baltimore Sun* editor who mentored many wineries on the East Coast. Asked about this, she says, "In fact we talked to Philip Wagner and he encouraged us."

An early neighbor of Emma and Jim Randel's is Dick McCormack, who started the nearby North Mountain Vineyard and Winery. Dick says, "I bought the land in '81, planted the vineyard in '82 and built the winery in 1988." Emma describes Dick as Jim's protégée. Dick seconds that and says, "In those days everyone helped the other guy."

North Mountain is still in business, but Dick sold it in 2002. He had health problems, including two kinds of cancer. He says, "It kind of wore me out. It was very difficult for me to get the competent help I needed."

Emma explains that when she opened up the winery, "we were astounded by the number of people who showed up on opening day. My husband did the cellar tour and I did the vineyard tour." The next day, they switched jobs. As the years rolled on, they planted more grapes, including vinifera. It is perhaps ironic that they even bought grapes from Bob Dickerson, who, according to Emma, was at that time head of the Bureau of Alcohol, Tobacco, Firearms and Explosives (ATF).

Jacques Recht

Most of the wineries in Virginia are in the Northern Virginia area and the region around Charlottesville. But a new wine trail has sprung up around an old plantation and winery called Ingleside.

In 1980, a Belgian named Jacques Recht built a homemade catamaran and headed across the Atlantic with his wife Lilian to the Chesapeake Bay. The

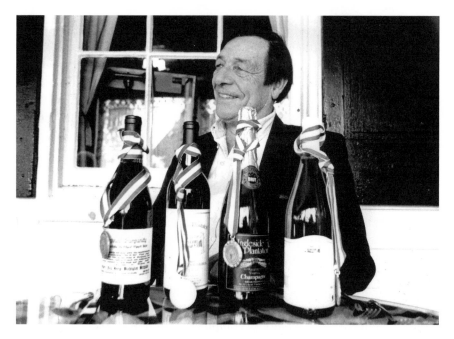

Jacques Recht with award-winning Ingleside Vineyards wine. *Courtesy of Lillian Recht.*

Jacques Recht of Ingleside Vineyards with John Rogan, owner of Boars Head Inn and Oakencroft Vineyards. *Courtesy of Lillian Recht.*

couple was inspired to visit the estuary after having read James Michener's novel *Chesapeake*. At that time, Carl Flemer, the owner of Ingleside Winery, was starting to plant grapes with his son Doug. Their curiosity piqued and swayed by Carl Flemer, Jacques and his wife agreed to stay at Ingleside a short while before finishing their circumnavigation of the globe. They never left. Jacques died in 2009, having retired from Ingleside to work at Athena and other vineyards. His wife continues to sell wine barrels.

Echoing the same refrain as Gabriele Rausse regarding French hybrid grape vines, Jacques says, "Meredyth existed when I arrived here in 1980. Archie Smith Jr. started that and Archie Smith III was taking care of it. They only had hybrid grapes. The wines were of course hybrid vines and could not compete with vinifera."

Jacques arranged for Ingleside to get its license. He says, "Carl Flemer had done some home winemaking. He made some homemade seyval, which was okay. But the rest was awful."

Equipment was difficult to obtain then. Jacques says that in order to get some wine tanks, they went to Atlantic Welding in Maryland. "We still have them." Jacques and Carl got other equipment from Philip Wagner, who had ordered it from Switzerland.

LUCIE MORTON

Lucie Morton is a viticulturist who lives near Warrenton. She spent her early days working in Virginia and then moved on to Australia, New Zealand and California. She is known around the world for two important discoveries. First, she predicted that California vineyards were at risk of decimation due to the phylloxera pest and improper rootstock. The experts scoffed, but Lucie was right, and many vineyards were replanted. Second, she said that certain California nurseries were peddling plant material that was infected with a then unknown virus. This earned her the enmity of the scions at UC Davis when she was proved to be correct. Other scientists were more appreciative, and a couple even named a plant pathogen in her honor. Now Lucie is focused on Virginia again, and many of the newer vineyards have signed her up as their consultant.

Lucie talks about the vineyard she started for her family. She says, "I planted my vineyards in King George County in 1973." She grew grapes for hobbyists, gave classes and sold equipment to home winemakers. She says, "Two of my home winemaker students were Carl Flemer and Felicia Rogan. Felicia decided that she and John would like to go commercial. So I helped them get started." They planted what became known as Oakencroft Vineyards.

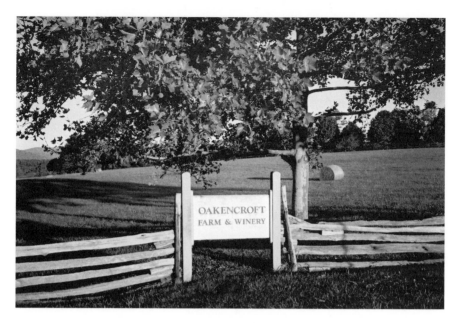

Oakencroft Farm and Winery sign. *Courtesy of the University of Virginia.*

OAKENCROFT VINEYARDS

You have to know Felicia Warburg Rogan to know how absurd it must have been to see her at Lucie Morton's vineyard one fall day in the 1970s. Felicia is a Park Avenue hostess, a patron of the arts and a streetwise New Yorker. She could be a bit intimidating for the uninitiated, especially for those who mispronounced her last name—it sounds like "rogun," not "rogan." Archie Smith calls her "a piece of work." So it is comical to hear Lucie tell about how when Felicia came to one of her grape harvests, yellow jackets were swarming in a cloud. Everyone was pressing grapes and making wine when suddenly Felicia ran up the hill without her pants—yellow jackets had swarmed inside and Felicia had partially disrobed to avoid being stung.

In the office of her winery, Felicia talks about her winery and how she got into the wine business. "I knew Treville; he was up in Middleburg. I met Lucie Morton, who was a noted viticulturist. Her mother was a friend of my late husband. She was running a vineyard for her family. I had lived in New York all my life and hadn't picked grapes." Felicia had traveled to Europe and knew about wine, so Lucie suggested, "'Why don't you try making wine?' It intrigued my husband, and she gave us a carboy. Well my husband made what

Entrance to the tasting room. *Courtesy of the University of Virginia.*

View of the vineyard. *Courtesy of the University of Virginia.*

I called garage wine in the back of the garage for several years. It was dreadful but it was amusing to do. Lucie said, 'Why don't you plant some grapes?' and we planted fifty acres." She continues, "Thanks to my husband, we have the catbird's seat because we are the closest winery to Charlottesville. I would like to coin a new slogan: 'We are on the way to everywhere.'"

In 1978, they planted vines. Her assistant, Carol Graves, has been with her for twenty-three years. Phil Ponton is another longtime employee, having previously worked alongside Gabriele Rausse planting grape vines at Barboursville.

Commenting on the import of Virginia Tech to the industry today, Felicia says, "I was the first chairman of the Virginia wine growers' advisory board. We lobbied for funding from the general assembly. It was necessary to get a viticulturist as well as an enologist, and in my opinion it has made all the difference in terms of the quality of the wine."

She continues, "None of us knew what we were doing when we started out. All of the new people have benefited from what you call our pioneering. Lucie was the one who helped most of us in the beginning who were planting French American hybrid grapes. I didn't want to do that; I never heard of them. I liked merlot and chardonnay but thank goodness we did put in the seyval because it has been the backbone." She explains that her site gets terrible frost so sometimes her vinifera gets wiped out. She adds, "Gabriele helped us with the machinery. He was certainly wonderful with such humor and patience."

Oakencroft closed its doors at the end of 2008. Folks will remember Felicia for her winery and her husband John for donating the Boars Head Inn to UVA.

NAKED MOUNTAIN

Naked Mountain Vineyard is tucked into a hollow on Naked Mountain, high above the killing frost. The steep mountain vineyard looks the way a vineyard might look in Germany, New York or parts of France, where vineyards are tucked into the hills to find the perfect microclimate. Asked whether she has let her tractor slide into the trellis, owner Phoebe Harper says, "Not yet."

Thomas Brady, in the 1983 summer edition of the *Vinifera Wine Growers Journal*, wrote,

> *The site they selected for their vines is at about 900 feet on the east slope of the Blue Ridge Mountains. The high elevation tends to delay bud break in the spring and reduces the average humidity during the summer. It also contributes*

to good year round air and water drainage. The exposure is south, southwest, with shallow, low pH soil that dries swiftly after rains.

Interviewed at her winery on a rainy day in April 2009, Phoebe says that she and her husband Bob started their vineyard here in the upper reaches of Fauquier County in the 1970s. She says that in the 1960s,

Bob and I were making amateur wine in our home in Falls Church. We wanted a source of fresh grapes rather than buying concentrate, which we had done previously. Some good friends of ours own a farm in Rappahannock County, so we planted twenty-four vines there. We learned a lot of lessons about grape growing; particularly we learned about frost and vine selection. We started looking around for property; that is how we came to purchase this property on Leeds Manor Road. We bought the land in '73. The first grapes went in the ground spring of '76.

Now their tiny winery has grown to a respectable 6,500-case winery.

She continues, "We decided we were only going to plant and work with the vinifera varieties. That is all we ever had here." The vineyard originally had sauvignon blanc, riesling, chardonnay, cabernet sauvignon, merlot and gewürztraminer, most of which has all been ripped out and replaced with just chardonnay and riesling. She says that it is too hot in Virginia for gewürztraminer, as this early-ripening variety ripens during the hottest month of the year: August.

"The first grapes went in the ground in the spring of '76. We were growing grapes and continued to expand the vineyard from '76 to '79 and sold grapes to both Meredyth and Shenandoah." Calling Treville Lawrence "kind of a pied piper," she says that he arranged a grape-growing and winemaking class with Hamilton Mowbray, the noted Maryland grower and winery owner.

Realizing the need for mobile wine bottling on the East Coast, the Harpers established the first one, called the Filling Station, in 1991. The service initially was provided to over thirty wineries in Virginia and neighboring states. The line was sold in 2003 and continues today as the Bottle Boy.

Phoebe says, "Based on Bob's ability as an amateur winemaker and encouragement from our friends who said you need to take it to the next level, we opened our winery in 1981. We sold our first bottle of wine in March 1982 and my dear sister was my first customer." Other winemakers have come and gone at Naked Mountain in recent years. Asked who is the winemaker now, she says, "At this point, Bob has resumed those duties."

Horton Vineyards

Denis Horton is a blunt-spoken Missouri native, an office-supply salesman turned grape entrepreneur. He is given to corny expressions and one-liners, calling certain grapes, for example, "bulletproof," meaning that they weather the weather well. He makes fine wine but smokes cheap cigars at his cavernous winery, where he stands behind the tasting room counter voicing his pointed opinions. At any other venue, you might think him a union boss, but here in Virginia he is known as, well, a blunt-spoken Missouri native—albeit one who is always forthcoming with information and eager to help debutante grape growers who want to start a winery or otherwise get into the business.

Denis Horton and his wife Sharon—who toils some twelve hours per day overseeing the labor of more than a dozen legal migrant farmworkers—are not pioneers in the sense of Gabriele Rausse, Lucie Morton or Doug Flemer. But more than anyone else, they have adopted ideas put forth by Drs. Zoecklein and Wolf of Virginia Tech and planted the grape varieties for which Virginia is well known today.

Horton Vineyards is a large winery that sells everything from blueberry wine to pear port. Denis knows that some of his detractors laugh at him for having more than thirty varieties in his winery, but he says that he "laughs all the way to the bank." He is an astute businessman and knows he cannot plant exclusively the grand cru varieties favored by the learned wine enthusiasts because the average wine buyer has not been sufficiently educated to buy exclusively that. In the young Virginia wine industry, it is his burden to make not only wine, but to make the market as well.

Denis Horton has propelled the varieties cabernet franc, norton, tannat, petit manseng and viognier and made them synonymous with Virginia. A lot of people cannot even pronounce the word "viognier." But when Denis Horton first bottled it in 1993, people in the industry took notice, including Robert Parker and officials for several international wine competitions. Bruce Zoecklein, the noted enologist at Virginia Tech, gushes about the vintage. Daniel Shanks, who selected wines for the Bush White House, explains that he was so impressed with the 1993 viognier that he stocked it in his Napa Valley restaurant, Domain Chandon.

Denis says, "It probably put Virginia on the radar screen. Even Robert Parker wrote it up as probably the best rendition of viognier made in the United States." Denis laughs that the only place his wine did not get a gold medal was at the Virginia Governor's Cup. "It brought our product to the attention of the Virginia people."

Denis moved to Virginia from Missouri, where he lived a mere block from Stone Hill Winery, known for planting the American variety norton. After

getting tossed out of the university in Missouri for bad grades, Denis came to Northern Virginia, where he opened a business supplying document shredders and other machinery to the federal government. He was so successful that he soon found himself with enough money to buy the insolvent cooperative winery Montodomaine.

"Having been familiar with norton specifically, that was commercially the first vines that we planted." In the fall of 1989, he incorporated his vineyard and started planting. He complains that no one had heard of norton and they only wanted to give him $300 per ton for it, which is less than it costs to grow. Looking at the prospect of hauling grapes all over Virginia for a loss, he decided that it would be more profitable to put it in the bottle.

At that time, the Montodomaine cooperative had gotten into trouble. The five or six growers who owned the cooperative were paying themselves fourteen dollars a bottle. "No one was running the ship."

"I think I wrote them a check for about $359,000 or something like that. And the facility was mainly designed to do about six to seven thousand cases. The second year we did about thirteen thousand cases." Montodomaine already had distributors around the state, "so it was easier for me to move our brand-name Horton in and among the Montodomaine name. At the end of year two, I was asshole deep in wine and nowhere to put it."

Denis has his imitators, and he welcomes them with enthusiasm, knowing that they can only help grow the brand and spread the word of Virginia wines. Among them is Jenni McCloud of Chrysalis Vineyards, who has made it her mantra to spread the word on the American variety norton. She has repeated Denis's success with viognier and perhaps surpassed it, winning top accolades at the San Diego wine show a few years ago. Stephen Barnard, the winemaker at Keswick Vineyards, has also done well, likewise winning top award for white wine at the Atlanta Wine Summit for his viognier.

Jenni gives Denis credit for being the pioneer with regard to norton and viognier. But she claims credit for being the first to legally bottle petit manseng and get it recognized as a varietal by ATF. Not to be outdone, Denis says, "We bottled it before any ATF approval. They never questioned us." They thought it was a name and not a grape. You see, in Virginia there is a rivalry among winery owners and their outsized personalities—but collectively they work as one team.

Today, Horton Vineyards is setting precedent again, planting pinot tage, which is popular in South Africa. It is an early-ripening red grape like pinot noir, but because it has a thick skin, it holds up better in the weather here.

Asked the reason why he planted petit manseng in Virginia, Denis ends with a word: "Bulletproof."

THE ITALIANS

Americans tend to have an Anglican-slanted view of history. We write of the English landing at Jamestown in 1607 and making barrels of wine from the local grapes whose towering vines grew so vast that their weight threatened to bring down the trees into which they grew. But the Spanish came to the Americas far earlier, founding the cities of Saint Augustine, Florida; Cartagena, Colombia; and Santiago de Chile in the sixteenth century. Wherever the Spanish went, the Catholic Church and the Jesuits went with them, planting mission grapes, called "país" in Spanish, for their sacramental wine. So was the Iberian or Anglo-Saxon the first to spread the culture that is wine to the New World? Clearly the Spanish were the first to plant vinifera in North America, successfully growing the mission grape in California in the eighteenth century. In Virginia, the first commercial vinifera was grown by Piedmont and then Barboursville Vineyards.

In a house filled with books, the aroma of Italian cooking wafts from the kitchen as Gabriele Rausse pours viognier, while his son Tim, who works as an assistant winemaker at Blenheim Vineyards, arranges logs in the wood stove. Tim points to the second hand on the clock in the kitchen and says that Kirsty Harmon, the Blenheim winemaker, will show up at exactly 7:30 p.m. On cue, when the second hand reaches 12, headlights appear in the driveway and she is here. Gabriele has made risotto, which he insists must be eaten when it is finished and not a moment later. His friend and coworker from Monticello, Christa Dierksheide, a PhD historian, sautés tilapia.

Sitting at the head of the table, Gabriele pours myrtle liqueur from Sardinia. Gabriele labels this aperitif "precious" as he relates the tale of the early planting of vinifera at Barboursville Vineyards. The eyes of this thoughtful man tear up at the mention of his wife, who left him. He says that with her departure, he

has lost the energy to finish building the studio that sits behind the house. Were it not for his three kids, all of whom went to the university, including one who is working in Spain, he would give up on the winery whose tanks and barrels fill every corner of his winery building next to his house.

Gabriele Rausse lives on a 220-acre timbered plot of land just down the road from Monticello. This property, which he purchased in the 1980s for $500 and $1,000 per acre, is now worth many times that, located just minutes away from the Kluge Estate and Jefferson Wineries. Gabriele works at Monticello, where he grafted the same grape vines that Jefferson planted in 1807. The vines were planted by his brother-in-law under the direction of Gabriele and Peter Hatch, a historian who reconstructed the vineyard from Jefferson's own notes. The vineyard is a widely varying collection of different grapes that individually are not enough to make much wine, but there are 350 vines of sangiovese. Jefferson never successfully made any wine at Monticello, but Gabriele has. He bottled the first vintage of sangiovese there in 1997. He made a 1998 vintage as well, but the feds in their wisdom made him pour it all out when they discovered that Monticello had no winery license. So Monticello wines are now made in the basement of Gabriele's house, the location of the Gabriele Rausse Winery.

Gabriele tells the story of the early days of grape growing in Virginia. He says, "I think the first person to plant vinifera in Virginia was a friend of Treville Lawrence, the name was Christopher Martin, who lived here in Charlottesville. When I visited him in '76, he had an acre of beautiful grapes. He had gamay, riesling and cabernet sauvignon. He had one acre and he was taking care of it like a garden and he was making wine for himself."

Gabriele came over to America with his boss, Gianni Zonin, to buy a property and then plant a vineyard in Virginia at Barboursville. The lore of Thomas Jefferson hangs over the property, for this farm once belonged to Virginia governor James Barbour. His house, designed by Thomas Jefferson, burned to the ground. All that was left was the brick foundation.

Gianni Zonin is a sixth-generation Italian winemaker whose family owns eleven estates with 3,075 acres of vineyards in Italy. One of his handsome sons, Francesco Zonin, peers out from pages of the *Wine Spectator* magazine, which advertises his Italian labels. Some people assume that Zonin inherited his vast wine empire. Gabriele says that Mr. Zonin built up the family business from a large distillery that was left to him by his uncle.

An article from *Italian Wines and Spirits* that was reprinted in the 1984 *Vinifera Wine Growers Journal* says,

> *It all began in 1976 when a British group proposed to Gianni Zonin that he enter a company to develop a farm of 800 acres. From Italy, he sent a young*

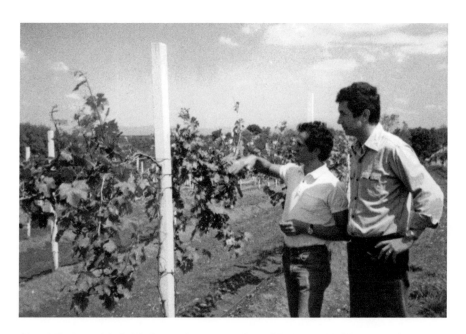

Gianni Zonin and Gabriele Rausse in the early days of Barboursville Vineyards. *Courtesy of Gabriele Rausse, Monticello.*

man of the Valdagno, who was only slightly beyond 30 years of age and who was quite freshly graduated from the agrarian science school in Milan. Gabriele Rausse set out vitis vinifera and the results were catastrophic.

Gabriele confirms the catastrophe, saying that half of the three thousand vines planted that first year died.

Vinifera vines planted in North America and Europe are not usually planted on their own roots. The top part of the vine—which would be merlot, chardonnay or another European variety—is grafted onto the bottom part of an American vine, which is tough enough and grows roots rapidly enough that the vine is not killed by phylloxera insects that live in the soil. Gabriele says that the vines he got from a grower named Byrd in Maryland were not grafted properly to survive the winter, so Zonin proposed to Gabriele that he graft his own vines.

Today, in California, nurseries sell what are called "green potted plants" to growers in California and what is called "dormant rootstock" to growers in the East. These are American rootstock, which have been grown in the vineyard and then had a bud of vinifera grafted onto the top. The bud grows for one season and then is dug up, put into refrigeration and set out into the vineyard the following year. Gabriele says that green potted plants are

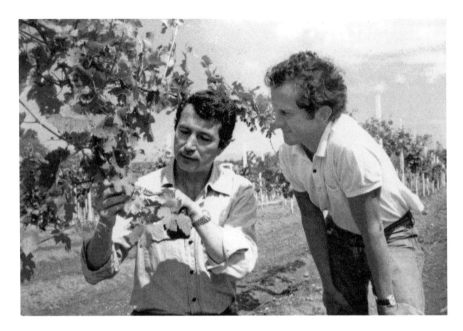

Zonin and Rausse. *Courtesy of Gabriele Rausse, Monticello.*

sufficient for a California winter but not for a Virginia one. At that time, there were no dormant rootstock available. So Gabriele did at Barboursville what California and New York nurserymen do today for vines shipped to the East: he grew the grafted rootstock for two, not one, years in the protected environment of a nursery, thus giving the tender young plant an additional year to heal its wounds before facing the harsh temperatures of winter.

All the vines that Gabriele grafted lived through the following winter. These included pinot noir, pinot blanc, alicante bouchet, merlot, cabernet franc and gamay. Barboursville was so successful at planting vinifera grape vines that soon others lined up for advice and, more important, plant material. Gabriele says, "In 1978, we grafted 100,000 vines. We sold everything we had. Our nursery became an attraction because people did not have a good source to get grafted vines." His customers included Meredyth Vineyards in Middleburg and Oasis in Hume.

Gabriele says that Zonin had a friend named Mario di Valmarana who was working at UVA teaching architecture, and he encouraged him to come to Virginia to plant grapes. Zonin already was a partner in a vineyard in Australia that was not doing well. He did not want to open "yet another California vineyard," so he bought nine hundred acres of land in Virginia. Also, Zonin wanted a toehold in America in case the communists, who threatened to win local elections in Italy, nationalized his properties.

Seeking advice in the United States, Gabriele and Gianni flew out to the University of California at Davis and met with Professor Howard Olmo, a noted viticulturist. The professor was more prescient than the academics at Virginia Tech at that time—one of whom was a teetotaler Baptist opposed to the production of any kind of alcohol. Professor Olmo said, "I will not live long enough to see this but I assure you that within years every state in the United States will have grapes planted." But his enthusiasm was not quite a ringing endorsement. Zonin says, "He told me that it would have been possible to cultivate vinifera there [in Virginia], but it would have been better in Napa or Oregon than Virginia."

Zonin continues,

> In 1961, I decided to visit all the viticultural areas in the United States willing to build a winery. I went back the second time in 1970, to California, with the idea of buying a vineyard over there. On my way back to Italy—there were no direct flights to Italy at that time—I stayed for a week in Virginia following an invitation of a friend of mine, Count Mario di Valmarana. It was the bicentennial anniversary of President Jefferson. I remember I studied his attempts to introduce vinifera in Virginia and I was fascinated by the idea of a president of the United States being a viticultural pioneer. I immediately fell in love with Virginia. It was spring and I had the chance to tour the area around Charlottesville and ask a few questions about climate and soil. After studying the microclimate of the region for a long time, I went back to Virginia in 1976, where I visited more than twenty-five estates. When I saw Barboursville, it only took me three seconds to understand that I found what I was looking for.

With the decision made, the Italians decamped, unpacked their gear and started to plan the winery. The people of the village of Barboursville were bemused looking at these Italian-speaking foreigners as they drove around in a big black Chevrolet Caprice at a time when there were few people in Virginia not of Anglo-Saxon descent. Gabriele says that the locals saw that car coming down the road and said, "Look! Here comes the mafia."

Cultural differences can make for some funny anecdotes. When Gianni Zonin visited the property prior to buying it, he noticed a man who was working at the farm. Zonin observed that he was working very hard and commented to Gabriele that he might be able to keep him on as an employee. But, noticing the wad of chewing tobacco in his mouth, Gianni wondered how this man's health would be with that tumor growing there (which was in fact just the wad of tobacco). In Italy, there were metal signs forbidding people to spit, so no one chewed tobacco. The following day, Gianni came back to the farm

and noticed the same fellow. Startled, he poked Gabriele in the ribs and said, "Look at that fellow. His tumor has moved to the other side."

Another odd sight at the Barboursville Vineyard is the big red plow that still sits in front of the winery. People today would call this a subsoiler, but in 1976 it was an odd sight indeed to see a plow designed to dig four feet into the soil. No tractor could pull that deep, so Gabriele bought a bulldozer. The idea was to give the roots room to dig deep into the soil, where they could get water in times of drought. That was supposed to help the vines survive the onslaught of powdery mildew, which is a mildew that attacks grapes, strawberries, squash and most plants in farms the world over.

The 1950s' model bulldozer would be assigned a more onerous task as well: to push over the winery building as it was burning. The previous owner of Barboursville had rented the land to a sheep farmer who said that the soils of Barboursville were only suited for sheep and not wine grapes. This farmer was not happy to be pushed off the property, but Zonin offered him fifty acres of land in recompense. The farmer also happened to be the chief of the local fire department and was on hand when the winery mysteriously caught fire. The wine was not burned, but the top of the winery was filled with hay that burned for four days. The police said that this fire was caused by arson. Gabriele had pushed the smoldering ruins into a pile and the police said that in so doing he had destroyed whatever evidence could be used to find the arsonist. The fire chief asked Gabriele if he had any enemies. Looking Gabriele in the eye, he said, "Am I one of your enemies?" Dejected, Gabriele flew back to Italy that Christmas to meet with an even more despondent Gianni Zonin, who asked Gabriele what could be done to protect the property. Gabriele said that there would be no more threat from this farmer.

When Gabriele first planted the vineyard, word of the Barboursville experiment had spread to Richmond, where the commissioner of agriculture cast a spurious eye. Growers in Virginia who had already been planting French hybrids were not pleased with what Barboursville intended to do. The commissioner summoned Gabriele down to explain what he was doing.

The commissioner told Gabriele that tobacco, and not wine, was the future for Virginia. Gabriele says,

> *In 1978, the commissioner of agriculture invited me down to Richmond. There was a roundtable with twenty-four scientists; each of them explained to me why I could not be successful at growing vinifera. The plant pathologists told me about the disease. The virologist told me about the viruses and so on. I told the commission, "I am sorry you disturbed so many people to tell me to go home. I am in the land of freedom and I don't see why I shouldn't do what I am doing." Professor Drake, professor of plant pathology at VPI [Virginia*

Tech], *said, "As long as you throw away the money of the people you work for that is perfectly all right with us. The moment you get a Virginia farmer excited about something that does not make any sense we have the duty to step in and stop you."*

Today, an aspiring grape grower on the East Coast can look on the websites of Cornell, Penn State and Virginia Tech universities for information on how to combat black rot, downy mildew, Japanese beetles and other diseases and pests not found in California. But in 1976, when Barboursville had a problem, Gabriele said, "We would call Italy."

The vineyard at Barboursville today is much changed from thirty years ago. Luca Paschina flew over in 1990 to take over for other winemakers who had succeeded Gabriele. Gabriele stayed on as vice-president for four years and continues as a board member, but he moved on to plant grapes at Simeon Vineyard, which became Jefferson Vineyards, and to work at Monticello restoring Thomas Jefferson's 1807 vineyard.

Gabriele is obviously proud of his work at Barboursville, but the initial rootstock that he purchased from California was infected with viruses and a vascular disease called "black goo," which had first been identified by Warrenton viticulturist Lucie Morton. Black goo and other viruses were a problem for vineyards in California as well.

When Luca came onto the scene, he began to rip out all the old plantings so that none of the original vineyard remains. The old casarsa trellis system that was fashioned from locust trees that had been split by hand was replaced by concrete posts imported from Europe and a vertical positioning shoot trellis, which is what is most widely used in Virginia. Later, the concrete trellis posts were replaced by steel ones, which Luca says were less expensive than pressure-treated ones.

Luca says that he ripped out the alicante bouchet, a grape used to add color to wine, and malvasia. Gone, too, are the French hybrids seyval and rayon d'or that Philip Wagner had suggested be planted in a low area unsuitable for vinifera. Luca says, "All the plant materials in the '70s in America were terrible. There were viruses and very uneven genetic materials. Within the same shipment you might have different kinds of chardonnay clones." Receipts from the nursery attest to the confusion, as one is labeled "pinot chardonnay," which of course does not exist. He says that the rootstock was too vigorous back then to make good wine because "in those years, the goal was to get a lot of grapes to get high yields. That was the philosophy. We had to reconvert everything."

Luca planted barbera, two clones of chardonnay, pinot noir and riesling. Viral problems continued. "All those acres planted, they are gone. It was

infested with viruses. It takes ten years for that to show up." Then he started buying vines from Joachim Hollerith's California nursery. Joachim is a German who also planted Prince Michel and Rapidan River Vineyards in Virginia. Luca says, "Since that point on, we had no problem." To make sure that viral problems do not come back and damage the vineyard, Luca sent samples of his vines to the University of California at Davis, where they all tested negative.

The tasting room at Barboursville hosts tens of thousands of tourists annually, and the winery is continuing to grow. Today, it has cleared an additional fifty acres of forest on which workers are planting rye grass, disking and subsoiling the soil to expand the vineyard, although the big red plow subsoiler sits idle.

THOMAS JEFFERSON AND CHARLES CARTER

A ny book on Virginia wineries and vineyards must include an essay on Thomas Jefferson, for the former president and author of the Declaration of Independence is the most famous grape grower in Virginia. As has been written before, Jefferson never made any wine at his Monticello estate, but it was not because he did not try. He planted and replanted his vineyard several times and spent a great portion of his civil service salary as president on his wine cellar. But at that time there were not modern chemical sprays available that can be used to control fungal diseases like powdery mildew and botrytis that plague grape vines, strawberries, squash, apples and other plants. Also, the soil in Virginia was infested with root-devouring phylloxera insects. So the vines that Jefferson planted withered and died before they could be made into wine.

It would be truly difficult to write anything new on the life of Thomas Jefferson. Every facet of Thomas Jefferson's life and work has been documented in countless journals. There is an entire Jefferson Room in the Library of Congress, and the collected Papers of Thomas Jefferson is twenty-seven volumes and growing. So the best way to write about Jefferson is to consult the work of others, and that is what we do here by quoting from the book *Jefferson and Wine*, first published in 1976 and edited by Treville Lawrence, who founded the Vinifera Wine Growers Association in Plains, Virginia.

Christopher Martin is a retired foreign service officer who planted a vinifera vineyard in Orange County prior to Barboursville planting its vines there. In Treville Lawrence's book, Martin wrote a chapter on Philip Mazzei, a wine merchant who came to Virginia from London at the encouragement of Thomas Adams, a businessman whom he met through Benjamin Franklin. The two men encouraged Mazzei to sail to Virginia to plant grape vines

and olive and fruit trees. He left for the colonies in 1773 with ten Italian grape growers just prior to the American Revolution. When he landed at Williamsburg on his fist day, he met George Washington, Thomas Jefferson and others. Mazzei had procured land in Augusta County, but en route Thomas Jefferson enticed him to stay in Albemarle County instead with a gift of two thousand acres of forest next to Monticello. Jefferson helped him arrange to buy fifty acres of cleared land for his vineyards and orchards on a place to be called Colle, next to Monticello.

Chad Zakaib, managing director of Jefferson Vineyards, writes in an e-mail,

> *Jefferson gave Mazzei an unknown number of acres, centered on the saddle between Monticello and Ash-Lawn Highland. Colle is the name of the home Mazzei built and then surrounded with vines (he's a Tuscan after all). Colle is across the street from the winery, owned and inhabited by the owners of Jefferson Vineyards. The vineyards Mazzei planted covered the entirety of the hills around Colle, which includes our Church vineyard and Apple Vineyard.*

Mazzei got caught up in events surrounding the American Revolution and did not write much about his vineyard for the next few years, so there is little existing record of what happened. Thomas Jefferson, after writing the Declaration of Independence, gave Mazzei one of the original five handwritten copies and then sent him to Italy to try to raise money for the war. Mazzei rented Colle to German mercenaries, called Hessians, whose horses trampled the vineyard. By 1778, the vineyard that Mazzei had planted was gone. He moved back to Europe, leaving behind one of his grape growers, Antonio Giannini, who worked at Monticello at least until 1812.

The *Atlantic* and *Vanity Fair* columnist Christopher Hitchens suggests in his biography of Thomas Jefferson that Philip Mazzei was in part responsible for the breakup in friendship between Thomas Jefferson and former president George Washington. Hitchens writes, "This seemingly harmless viticulturist had been invited to Monticello to assist Jefferson in his lifelong scheme to get Virginia wine up to standard." But Jefferson, while vice president under John Adams, wrote a letter critical of the administration of President Washington. Washington was then, as now, highly revered with saint-like deference. This letter was translated from English to French to Italian and back to English again, in which form it appeared in a newspaper in London. According to Jefferson, this version was mistranslated as an attack on the former president himself. Hitchens writes, "And it seems certain that, after the controversy, he never spoke or corresponded with President Washington again."

Thomas Jefferson and Charles Carter

In 1944, the American Philosophical Society published Thomas Jefferson's *Garden Book*. It mentions the following. In 1771, Jefferson planted five grape vines that had been sent to him by George Wythe. Two years later, he dug up fifty vines from the forest and added them to his vineyard. Then, in 1774, he planted thirty more vines. Notes from the *Garden Book* suggest that he turned his grapes into vinegar.

Treville Lawrence's book quotes a couple more familiar Jefferson comments regarding his vineyard. In 1786, while serving as ambassador to France, he wrote to Antonio Giannini asking, "How does my vineyard come on? Have there been grapes enough to make a trial of wine? If there should be I should be glad to receive here a few bottles of the wine." In 1806, he writes, "We could, in The United States, make as great a variety of wines as are made in Europe, not exactly of the same kinds, but doubtless as good." Finally, in 1809, he apparently gave up trying to grow foreign grapes, writing in a letter, "I think it would be well to push the culture of that grape [fox grape], without losing our time and efforts in search of foreign vines, which it will take centuries to adapt to our soil and climate." Jefferson had tried wine made from the Alexander hybrid, saying that it made a wine "as good as the best Burgundy and resembling it."

Peter Hatch is a historian working at Monticello. He studied Jefferson's notes and laid out the project to replant Jefferson's vineyard in 1985. Gabriele Rausse grafted the vines that went into the ground. Peter is still working in an office to the right of Monticello, next to where Gabriele keeps lemon and other trees in a greenhouse. Peter wrote in Lawrence's book, "Most scholars would concur that wine was never made at Monticello."

He goes on to write, "Jefferson's appreciation and knowledge of the world's finest wines has often been documented, yet his continual replanting of the Monticello vineyards suggests a perennial difficulty with grape cultivation." The vineyard planted in 1985 was the same as that which Jefferson had planted in 1807. Of the varieties planted, twenty-three were table grapes and twenty-three were wine grapes.

Philip Carter Strother is an attorney in Richmond who has long represented different wineries in their litigation with county regulators and others. In 2008, he purchased Stillhouse Vineyards, renaming it Philip Carter Winery. He had long known of his Carter family's ancient lineage in Virginia, but after purchasing the winery, he made a discovery that led him to claim the mantle "the First Family of American Wine." This is certain to raise eyebrows among those who believe that deference is due Thomas Jefferson. Here is where Philip gathered his documentation and proof.

Philip Carter Strother read in the book *A History of Wine in America*, by Thomas Pinney, that his ancestor Charles Carter received a prize from the

Royal Society in London for growing grapes and producing wine from his Cleve Plantation in King George County. Charles Carter was the head of a committee formed in Virginia in the wake of the collapse of tobacco prices to study alternatives to the tobacco trade, one of which Charles Carter suggested might be wine. Pinney writes:

> *In 1762 Carter, who by then had 1,800 vines growing at Cleve, sent to the London society a dozen bottles of his wine, made from the American winter grape "a grape so nauseous till a frost that fowls of the air will not touch it," probably vitis cordifolia, is meant and from a vineyard of "white Portugal summer grapes." These samples were so pleasing a taste—"they were both approved as good wines," the society's secretary wrote—that the society award Carter a gold medal as the first person to make a "spirited attempt towards the accomplishment of their vines, respecting wine in America."*

Philip Carter Strother celebrated this discovery by planting 1,800 viognier vines in front of his vineyard.

The key words in this selection from Pinney's book are "white Portugal summer grape." We have no drawings, so no ampelographer can verify that these were indeed vinifera grapes from Portugal and not some hybrid like Alexander. (Thomas Jefferson in 1807 planted the Alexander grape, which was also known as the "York Lisbon," Lisbon, of course, being the capital of Portugal. The Alexander variety had been dug up from the garden of the Pennsylvania governor William Penn's son Thomas about 1740. Lucie Morton writes in her book *Winegrowing in Eastern America* that William Penn had planted a vineyard in 1684.)

Pinney cites as his source *Memoirs of Agriculture and other Oeconomical [Sic] Arts*, by Robert Massie published 1768–82. A copy of this book, with notes penciled in the margin by Charles Carter's brother Landon, is in the University of Virginia library, a school founded by Thomas Jefferson. Landon Carter's Sabine Hall plantation is still standing on the banks of the Rappahannock River near Senator Mark Warner's Rappahannock Bend Vineyard. Landon himself had made wine from native American grapes whose foul taste was such that he boiled them and then added sugar to make the product palatable.

Memoirs of Agriculture reads:

> *The first accounts of the success of the premiums was in 1793, when Mr. Carter sent a dozen bottles of two kinds of wine, from grapes which grew in vineyards of his own planting in Virginia. The one of these kinds was the product of vines brought from Europe, the other of the American wild vines.*

They were both approved as good wines and the Society gave their gold medal to Mr. Carter, as the first, who had made a spirited attempt towards the accomplishment of their view, respecting wine in America.

The same book mentions that the award was the result of a contest:

As producing wines in our American colonies will be of great advantage to those colonies, and also to this kingdom; it is proposed to give to that planted, in any of our said colonies, who shall produce, within seven years from the date hereof, from his own plantation, five tons of white, or red wine, made of grapes, the produce of the colonies only, as such as, in the opinion of competent judges, appointed by the Society in London, shall be deemed deserving the reward; not less than one ton thereof to be imported at London; one hundred pounds.

After reading Pinney's book, Philip Carter Strother contacted the Royal Society in London, and a historian there, Sophie Cawthorne, helped him dig through the archives, translate the eighteenth-century longhand script and find a photographer who could photograph the correspondence found there, since they were in bound volumes that could not be taken apart. Letters between Charles Carter and an Englishman, Peter Wyche, discuss the vineyard and planting. Charles Carter wrote in one letter, "I have made from a vineyard of White Portugal Summer grapes some light pleasant white wine I wish it many profit in the spirit to send you a taste."

Wyche, in a 1761 letter commenting on the foul-tasting native American grapes, said that the worst grapes in France were used to make brandy there and suggested to Charles Carter that he might give wine from native grapes to his slaves. In that same letter, Wyche promised to send Charles Carter grape vines from Europe and mentioned another planting in America that had not been successful. Peter Wyche thought that Virginia might be too hot, so he suggested allowing the vines to grow into treetops so that the grapes would be protected by the tree canopy and not burst in the heavy rain.

As for other evidence as to whether these grapes were in fact European, we have the word of Royal Governor Francis Fauquier, who wrote and signed the following declaration in August 1763:

I do hereby certify that the above named gentlemen who have attested, the original of which this is a copy, are men of character in this colony. That Mr. Boucher is minister of the parish and Mr. Seth a magistrate of the county in which the vineyard is planted, and that full faith and credit ought to be given to everything they they [ajour] concerning the same.

He is referring to documents signed by a committee of men, including Jonan Boucher Rector, Thomas Seth and others who had gone to visit Mr. Carter's vineyard in July 1763. Those men wrote:

> *At the Request of Charles Carter Esquire of Cleve we the subscribers visited a vineyard at the place of his residence and so hereby certifie [sic] he has growing in squares six feet distant fifteen hundred vines well set with fruit of the red and white Portugal grapes well proposed cultivated and enclosed. We the subscribers do hereby certifie that Charles Carter Esquire has growing and cultivated under the same inclosure [sic] as the above vineyard twelve hundred young vines of the European sorts white and red.*

What did Thomas Jefferson know of Charles Carter's vineyard? In 1762, Thomas Jefferson would have been nineteen years old and still studying law at the College of William and Mary. The first reference to growing grapes is from Thomas Jefferson's *Garden Book*, which states, "In 1771 Jefferson planted 5 grape vines sent to him by George Wythe." There are some sixty letters between Jefferson and a Charles and Landon Carter, but Camille Wells of the Department of History at William and Mary says that this is Charles Carter of Shirley and not Cleve. As to the Landon Carter with whom Thomas Jefferson corresponded, this was Charles Carter's son. That letter does not mention the vineyards.

LINDEN

THE APOGEE OF PERFECTION

Wine is now produced in all 50 states. After the big four (California, Washington, New York, and Oregon), however the quality and consistency suffer. Virginia's Linden Winery, led by Jim Law, is one bright spot in a state that always seems to promise more than it delivers.
—James Molesworth, Wine Spectator, *February 2009*

In France, there is a belief that soil is important to the quality of the wine. The district of Champagne is delineated by the chalky, alkaline soils that lie beneath the great vineyards there. Burgundy wines are said to have flinty mineral characteristics because the limestone in which they are grown allows the roots to grow deep, pulling up minerals from the soil. And an appellation in Bordeaux is called "graves" because of the rocky, gravelly soils found there. But New World winemakers are not so sure that only certain soils can produce premium wines. Dr. Richard Smart, in particular, is an Australian viticulturist whose book, *Sunlight into Wine*, mocked the notion that only the French can make great wine. He applied science to the empirical observations, which consequently became tradition and concluded that the reason the French wines were so good is there is an optimal balance between the number of leaves, the amount of fruit on the vines and the growth of the roots. If the vine were balanced with regard to these three measurements, then it would develop the proper ratio of fruit to foliage to produce wines that were not too herbaceous, overly tannic or lacking in structure. Dr. Smart said that optimal results could be produced outside of France with proper trellis design, pruning selection, selection of rootstocks and clones. His teachings have become de facto standards in eastern viticulture. Yet there

is one grape grower out there who has taken these ideas a step further, practicing what he calls "extreme viticulture," where he continually evaluates and adjusts each step of the grape-growing process to produce what just might be the best wines in Virginia.

Jim Law of Linden Vineyards says, "The way you make a great wine is you don't make any mistakes from pruning to bottle." When most winemakers conduct an interview with a journalist, they start in the tasting room or the wine cellar. But in an interview that Jim gave to Grape Radio in 2007, he started out on his knees in the vineyard clutching handfuls of dirt. Squeezing the dirt in his hands, he explained that if the soil contained much clay it would stay clumped together. Too much clay is not good, for it increases the water-holding capacity of the soil and its ability to retain nutrients. Soil scientists call this "catation exchange capacity." Soil clay particles called "colloids" are cations that have a positive electrical charge, thus holding onto negatively charged ions of magnesium and phosphorous, which of course are present in fertilizer. Vines grown on deep clay soils will be overly vigorous and produce low-quality grapes if the wrong variety is planted there. Jim said, "Merlot cycles shorter than cabernet sauvignon. So merlot is more suitable for deep clay soils." Moving a few feet over to another soil type, he explained that rocky soils are better for cabernet sauvignon. "We like rocks. The vines like rocks. They provide better drainage." Rocks displace soil, which reduces the amount of nutrients and thus makes for less vigorous growth and smaller, more balanced vines.

Jim told Grape Radio, "This is just one acre that we are on and we have three different soil types. We harvest by soil types and vinify by soil types." In a declaration sure to raise the eyebrows of those who are not his disciples, the high priest of Virginia viticulture, lecturing from high on his vineyard at 1,200 to 1,400 feet, said, "Soil type is more important to wine quality than clone or in some cases even variety." He explained by example that cabernet franc on two different soils can vary so much that "you wouldn't know that the resulting wines would be from the same variety."

Standing in one block of vines, Jim told Grape Radio that he first planted his vineyard in 1985 and for this particular plot tore it all out. He said, "After fifteen years I did not like what it was doing so I pulled it out. And that's what you have to do. You're not planting it for three or four years down the road, you are planting it forever." He said it takes a long time to plant vines and evaluate the fruit and resulting wine. "The vineyard does not start producing interesting wines until it is ten years old." He said that a very young vine will produce wine that is much different from another vine. So it takes a while to discern which vines on which soils are worth retaining.

In a challenge to conventional wisdom, Jim picks his chardonnay by acidity (see "The Grape Growers' Conference" for his explanation) and picks his red grapes based by soil. Shortly before harvest, he goes through the vineyard marking each vine by soil type so that the men harvesting the fruit will know which variety they will be picking on that particular day.

In the desert farming of California, where there is no rain during the growing season, growers control the size of the berries at véraison by simply turning the drip irrigation system on or off. But in Virginia, the rain falls from the sky and is not pumped from the ground or tapped from the reservoir. Nature has its own schedule for rainfall, unregulated by man. So to throttle the growth of the vines, Jim uses cover crops.

The farmers' cooperative must have thought Jim was a nut when he first marched in to order crabgrass seeds. After all, suburban homeowners spend a great deal of energy ridding their emerald green chemical lawns of this noxious pest. But Jim says that crabgrass is ideal because it grows low under the grape vines and emerges just at the time of véraison, when the grass can compete with the vine to reign in its vigor. He also plants creeping red fescue for this purpose, saying, "If the vine growth is very fast, I let the grass grow more to compete with the vine. If it is very slow, I might till or herbicide the grass."

Jim works closely with two growers, Richard Boisseau and Shari Avenius, to bottle single vineyard wines under their labels "Boisseau," "Avenius" and "Glen Manor." The growers and two of Jim's "wine grower apprentices," Gerard Kellas and Josh Grainer, meet with Jim three times a week as they taste the best wines of France, making careful notes with particular regard for the most difficult vintages there. "The goal is to learn." On this particular afternoon, Jim is sitting with Richard Boisseau and Gerard Kellas on the vineyard's sprawling indoor deck.

The textbooks would say that sauvignon blanc requires cool temperatures at night in order to make a wine with high acid and grass herbaceous flavor that is a characteristic of the best. This is called "diurnal temperature difference." Asked how, in hot and humid Virginia, Jim Law and Shari Avenius are able to grow such stellar sauvignon blanc (see the Introduction, in which Bartholomew Broadbent tastes the 2007 Avenius Sauvignon Blanc), he produces the 2008 sauvignon blanc and says, "This one is even better." Jim explains that Avenius Vineyard is at 1,400 feet elevation in a vineyard facing northeast, away from the sun. The diurnal temperature difference is there: "At September it starts to get pretty cold at night."

"Sauvignon blanc is not an easy grape to grow in Virginia. I don't recommend it unless you have the right site and you have a passion for it. It took Shari Avenius ten years to fine-tune it. We made a lot of mistakes. We tamed the vines down, got the vines in balance and it took off."

Jim does not participate in wine competitions anymore, including the Virginia Governor's Cup, having competed up to ten years ago, when he won for a late harvest vidal blanc dessert wine. He says that the great California wineries Stags Leap and Screaming Eagle do not compete in wine competitions and neither do the great châteaux of France. Wine competitions are for wineries that are on their way up the quality curve. Once they have reached the top tier, the only opinions that matter are those of wine writers like the *Wine Spectator*'s Robert Parker and Michael Broadbent, whose followers use these opinions to determine where to buy and when to drink wine. Jim does not participate in festivals either, and his tasting room had become so overrun by tourists on the weekends that he no longer allows the public into the vineyards and certain parts of the winery unless they have purchased a case of wine. While this might appear standoffish to others in the industry, quite the opposite is true. Jim attends the Northern Virginia Winemakers' Roundtable (see "The Winemakers' Roundtable" chapter), where he shares his knowledge with others, and he also attends panel discussions at Wineries Unlimited and the Virginia Vineyards Association trade shows and holds grape-growing and winemaking seminars at his winery. Finally, he writes for several publications. So he keeps no secrets and spreads his message to whoever will listen.

Asked to compare Virginia wines with the best from Europe, Jim says, "I cannot talk about Virginia wines. I can talk about my wines. I don't drink California wines anymore, because Europe is our benchmark. I think on the price-quality ratio we are right in the ballpark."

He and Richard Boisseau make "mad wine-buying excursions to nearby Washington, D.C.," where they spend a good portion of the winery's revenue on second- and third-growth Bordeaux, Rhône wines and those from Burgundy. Even free-spending Jim has a limit, so he does not buy much first-growth Bordeaux "because it is too expensive." He is a fan of Saint-Julien Château Léoville-Barton.

In France, as in Virginia, the blend that goes into the Bordeaux varies by vintage, as one variety does better one year than others. To illustrate this, Jim pulls from the cellar a precious ten-year-old 1998 Hardscrabble red and pours that alongside the 2008, of which he, Richard and the interns have had blending trials on this very day. The French have had hundreds of years to perfect their formulae. Of Linden, Jim says, "We are still learning. Some years in Linden produce riper, more concentrated cabernet sauvignon (2008), others ripen merlot, but not cabernet sauvignon (2002)." He says that the resulting blend reflects the vintage.

The difference between a ten-year-old Hardscrabble and a brand-new one is clear, as the older wine tastes of mushrooms, which is a flavor you will

not find in a young wine. One can see in this bottle how a wine develops complexity over time and how the followers of Michael Broadbent and Robert Parker hang on their every word as they judge when to drink and when to cellar their precious old Burgundies and Bordeaux. Following in the footsteps of these great wine writers, Jim posts to his winery's website not only tasting notes on the current releases and older wines, but also up-to-date tasting notes for older wines that have been held in the library and tasted anew.

Swirling the 1998 under his nose, the man with the trained palate speaks: "I haven't had this for a while. The tannins were a little ornery when it was young. The nose shows lots of the fruit. It has gotten lots of black cherry when it started off as red cherry. Some mushrooms. Some cassis. Nice structure. The tannins are still hanging out. It's coming together. It still needs a little bit of time. Very assertive tannins." The wine is impressive, but the ever restless wine grower is still not pleased, saying, "This fruit was picked too soon."

The 2008 is not even in the bottle yet, so a bottle with a stoppered cork is produced. Of this blend, he says, "Now we have more merlot and less cabernet franc. In the last ten years we have planted a lot more merlot." The 1998 is 65 percent cabernet sauvignon, 27 percent cabernet franc, 5 percent petit verdot and 3 percent merlot.

Vintage is everything for these growers, and when asked how was the weather in 1998, without hesitating they will say that it was hot and dry, with a hailstorm to boot. The hail ripped the leaves, fruit and shoots from vines, leaving a meager crop of one ton per acre.

Jim searches his memory for comparisons with outré mer wines and settles on the 1998 Cos d'Estournel. He produces two books of tasting notes by wine writers Robert Parker and Stephen Tanzer. Parker described that wine as "elegant, graceful, subtle notes of sweet oak and licorice, herbs and black fruits. Medium weight and ripe with sweet tannins," while Tanzer noted its "aromas of cassis, blueberry, sweet butter, leather, olive and violet. Dense, black fruits, graphite and minerals. Finishes long."

Asked again to focus on the question of how the Linden wines compare with the French, he says, "I ranked it [the Hardscrabble] with '98 [the Cos d'Estournel] because this is '98." Smiling, he finally concedes, "Ours is pretty good."

Next, he pulls out the Boisseau 2006, which is 43 percent petit verdot, 29 percent cabernet franc, 28 percent merlot. "This is the best Boisseau we have made. The nose shows complexity that is not just fruit and will evolve."

Jim is a writer, so we can read his own copious tasting notes posted on his website:

2006 was a good year. I would have to characterize the vintage as classic in that the growing season was about as close to typical as is possible. There were substantial swings in temperature and rainfall during the summer, but in fact, this is normal for Virginia. The red grapes ripened fully with good balance. They were by no means overripe. They were crunchy, red fruit, ripe. Cabernet sauvignon tannins were fairly supple, which is the best indicator of the quality of a vintage here. There was some dilution with late rains, which resulted in significant bleeding of the juice at crush. Dry, low vigor conditions lead to a very large fruit set and a potential enormous crop, with the puzzling exception of merlot which had cluster sizes less than half of normal. Late June gave us a deluge of rain, rejuvenating vine growth and worrying growers about disease. Leaf pulling around the clusters was done earlier and more meticulously as a result. Weaker vines, slowed by the dry spring were cluster thinned early and rigorously.

July and August went back to being dry and hot. As a result, vines stopped their growth earlier than normal, which is what probably made the vintage for us. It confirmed to me the importance of vine balance and having the shoot tips cease growth at véraison. Green harvest took place for the reds in early to mid-August. Young vines had very large clusters. Even one cluster per shoot was too much. This required shoulder (wing) removal to balance yields. Véraison was fairly uniform with the exceptions of cabernet franc and petit verdot, which required more meticulous thinning. By late August we were in the unusual position of hoping for rain just before harvest, as young and shallow rooted vines were showing water stress. We got more than we had hoped for in the form of Ernesto and 4.5 inches of rainfall. Very fortunately, there was no berry splitting or rot, but there was some dilution. I refer to September and October 2006 as the great obstacle course, with alternating sun and rain. This pushed back ripening of the reds, but because of more rigorous crop thinning, our harvest dates were normal. Crop levels seemed to have had a large impact on red wine quality in 2006. Harvest was 9/27/06 through 10/16/06.

Finally, he sums up his philosophy with one anecdote: "Great wine can only be made by palate-based decision making and not science. The analogy is to cooking. At the end of a recipe, it is always written, 'adjust seasoning to taste.'" That is what he does: adjust the blends by tasting them.

Migrant Workers in Virginia

Asked whether her husband will be deported back to Mexico, Maida says, "It depends upon the judge."

The Work

If you were to farm thirty acres of row crops like corn or soybeans, people would say that is not much. But thirty acres of grapes is quite a lot of work because each individual vine must be visited several times per year and carefully tended by hand. There are some machines that one can use to speed up the process, such as machines to harvest grapes and hydraulic pruning shears. But for the most part, wine grape farming involves much manual labor.

As winter turns to spring, dormant buds on the grapevine swell and turn rose and gold. Green shoots begin to emerge and unfurl as the frosty winds of late March give way to milder weather in April. At first, the vines grow slowly as the pendulum of weather swings back and forth between warm days and cold. But then June arrives, and the shoots take off, growing as much as one inch per day.

Left to their devices, grapevines would grow in all directions. The shoots would flop onto the ground and the canopy would become a deep tangle through which neither sunshine nor agricultural spray could penetrate, and humidity would build. The resulting fruit would probably rot, and if it ripened at all, the immature green seeds would make foul-tasting, bitter wine. So the farmer trains the vines to grow on the trellis, which holds the grapes aloft and allows air and sunshine to penetrate the leaves.

To make the best possible fruit, the farmer works from April to August to snap off laterals, pop off excess shoots, drop fruit that shows no possibility of ripening and even pluck off individual leaves to improve the air flow around the grapes. From September through November, the grueling work of harvest begins, and the farmer crawls beneath the vines to snip off the fruit and dump it in plastic bins. Winter offers only a couple of months of rest, as the dormant vines must be pruned. In January and February, these wooden canes slap the farmer on his frozen face as he works with numb fingers to cut off last year's growth and make ready for the new year.

All of this takes much labor. One single person working full time could farm perhaps five acres of grapes. But if the farmer owns twenty acres of vines or even a winery, he or she has to spend time marketing, filling out tax forms, tending the tasting room bar and, of course, making wine. So there is a need for full- or part-time labor, depending on the size of the operation. Enter the migrant worker, who for generations in California and, more recently, in Virginia has exhibited a desire to work that meshes neatly with the needs of the farmer.

ENRIQUE REYES VASQUEZ

Asked whether her husband will be deported back to Mexico, Maida says, "It depends upon the judge." Standing in her trailer home in Winchester, Virginia, clutching legal documents that he and his husband barely understand, Enrique Reyes Vasquez, fifty-one, and his wife Maida, thirty-one, relate the tale of how Enrique spent four months in jail for driving on a suspended license and violations of immigration law.

In 1996, Enrique and his wife climbed an eight-foot-tall wall at the border town of Laredo, Texas, when Maida was five months pregnant. They made their way to Rappahannock County, where Enrique worked for a cattle rancher whom he says "was crazy." He beat Enrique twice, once when he broke a spine on the hay baler, and withheld his wages. Enrique then found work planting grapes in Flint Hill. He and his wife both worked in the vineyards, earning seven dollars per hour and working ten hours per day. Each day he earned more than he would earn in one week working as a carpenter in Mexico. Soon he found regular work with a local grape grower that lasted for twelve years. On any day when there was not enough work with his regular employer, Enrique would work for either of the two farm labor contractors whom he knew. These are men whose dexterity with the English language has enabled them to make contact with the gringo

vineyard owners and arrange work for their employees, most of whom are illegal immigrants.

One of these contractors is Javier Martinez. Enrique worked for Javier in 1998. Enrique says that "he pays on time" and he "always had ten to twenty workers." Another farm labor contractor is Rito Garcia. Enrique says, "Rito Garcia had problems because he did not pay the workers and kept them locked up like hostages." He said that if they complained, Rito would threaten to call *la migra* (the immigration officials).

At first glance, Enrique's life here in the United States would appear to include all the trappings of the American Dream. He saved $7,000 to buy a trailer home for his wife and their four kids—all of whom are U.S. citizens by virtue of their birth here. His children speak English with no accent. His young wife no longer works. Their trailer is air conditioned and smells of cilantro and other spices, while tomatoes and roses decorate the front of this modest but well-maintained barrio of mobile homes.

But Enrique's world is quickly unraveling, for he has run afoul of the law. Last year, the police stopped him after he had been to a party in Warrenton, where he said he drank five beers. His license was suspended. But Enrique needs his license to drive to work, so he drove anyway and got caught in Martinsburg, West Virginia. The police asked him for his green card and social security number and he showed them his Costco membership card and his Virginia driver's license. Latinos use two last names: the last name of their father and the last name of their mother. This, of course, does not fit into the gringo's computer system, so Enrique understands that to be the reason he was charged with "providing false information to the state police." He spent thirty-two days in jail in Martinsburg, and upon his exit the judge packed him off to two different federal detention centers in York, Pennsylvania, and Raymonsville, Texas, for three months. Now he has a court date with an immigration judge in Arlington, Virginia.

Immigration has been in the news a lot lately, but Mexicans have been coming to America to work in agriculture for generations. Enrique's father came here to work in watermelon and cantaloupe fields under the now defunct Bracero guest worker program. Writing in 1961 about the aftermath of the Mexican Revolution of 1910, Octavio Paz, the Mexican Nobel Prize–winning poet, wrote, "Despite these accomplishments [land reform], however, thousands of our rural citizens live in dire misery, and other thousands have no recourse but to immigrate to the United States each year as temporary laborers."

GUILLERMO

Standing in the wet end of a chardonnay vineyard repairing a deer exclusion fence, Guillermo is another Mexican migrant working in Virginia. We cannot print his last name or the name of his employer, for Guillermo is an illegal alien and could be deported if he were to, say, venture into Prince William County, where the police check your status, or happen to go into any office of the IRS, for he does not pay income taxes.

Guillermo says, "I crossed [the border] in 1990." He, like Enrique, paid a coyote, a human smuggler, to help him across the border in Arizona. Today, he drives a pickup truck and carries a cell phone that he uses to find work on the weekends—during the week he works full time at this winery. Guillermo and his friends do not stand around on street corners looking for work like some newly arrived *campesinos* (peasants). Instead, they have built up relationships that keep them employed most of the time. He works hard and often. He says that when he prunes apple trees, he "can do the work of four men."

Guillermo is a smiling and seemingly happy man, but he has suffered a great tragedy. He and his first wife are separated and he sends money home each week to his children in Mexico. Two years ago, he paid a coyote $3,000 to help his second wife, her brother and three children cross the border into the Arizona desert. Relating the tale whose date he cannot forget, he says, "On July 15, the coyote abandoned them in the desert because my brother-in-law was sick and the coyote did not want to help them. I do not know if they are alive or dead." He shudders as he says this; his Latin machismo gives way just for a moment. His wife had been with him in Virginia but had gone back to Mexico because her mother was sick.

When Guillermo first came to Virginia, he worked in a vineyard in Leesburg. His friends had told him that there was a lot of work there. He lived five people to a room in an apartment. One day, his friend invited him to work in the garden of another vineyard owner. The owner was trying to fix his tractor, and Guillermo says that he did not know what he was doing so Guillermo lent a hand. Guillermo had worked in Mexico driving tractors and trucks for 250 pesos (twenty-five dollars) per week. The owner then asked Guillermo if he wanted to work the harvest for two months. That was two years ago, and Guillermo is still gainfully employed.

Guillermo earns ten dollars per hour, which his employer pays him in cash. He pays no social security or income tax, and the employer obviously saves the expense of paying social security tax on his wages as well. The vineyard owner says that he would like to pay taxes but the government would not allow him and it has become more difficult for illegal aliens to obtain false social security numbers, as had been the practice previously.

Although Guillermo lacks papers, he has a driver's license. Like several other migrant workers interviewed, Guillermo got his driver's license in North Carolina. He says, "I went to North Carolina in order to get a driver's license with my passport and birth certificate." He does not need a license to drive his truck, since he has plates that say "farm use only."

Barboursville

At Barboursville Vineyards, two Mexicans have taken a tractor apart. They are working on the clutch that powers the PTO (power take off), and they need to divide the tractor nearly in half to get at the other clutch, which connects the wheels to the transmission to the engine. Vineyard manager Fernando Franco explains that it is better to do this work themselves rather than ship it off to the New Holland tractor dealership, for they would keep the machine for three weeks in this busy growing season.

Standing in a block of cabernet franc vines, Fernando explained that he came as a student from El Salvador to Virginia in 1981. He overstayed his tourist visa and was granted legal status under Ronald Reagan's amnesty program in 1988. Fernando is different from the many men he manages, for he has a university degree. Educated in agronomy, when he came to Virginia he took university courses at Germanna Community College and Virginia Tech, where he learned to speak English.

Fernando made friends with Joachim Hollerith of Prince Michel Vineyards, who is well known to longtime grape growers in Virginia as one of the early pioneers here and for his grapevine nursery business in California. Fernando says, "We became friends and he asked me to work for him." He honed his talents in East Coast viticulture and commuted back and forth to California to tend the vineyards there. He was offered a job by Barboursville ten years ago. Fernando asked the Belgian Duke who owned Barboursville for permission to leave and interviewed with Luca Paschina, the general manager of Barboursville, and Gianni Zonin, the owner.

Although Barboursville harvests much of its crop manually, it also has a lumbering automatic harvesting machine because, as Fernando explains, even his many workers could not possibly harvest six hundred tons of grapes by hand. Some Virginia vineyards employ undocumented workers on a spot basis; a few offer them full-time work; and some vineyards hire no migrant workers at all. Barboursville is different from most vineyards, for its full-time migrant workers are all legally employed under the government's H2A visa program. Of his many workers Fernando says, "First they are my friends and second my workers."

Joachim Hollerith, founding winemaker at Rapidan River and Prince Michel wineries, pulling wine from a barrel with a wine thief. *Courtesy of Phoebe Harper.*

On CNN, Lou Dobbs rails against illegal immigration nightly while business and agriculture clamor for a guest worker program. But one worker program is already in place: the H2A visa program, whose every step is highly regulated by the feds. Of the visa program and his workers, Fernando says, "[It is] totally worth it. Some of these workers have been here already. They know what to do. They do not need much supervision. There are no people here [besides the foreigners] who want to work."

Explaining the process, he says, "We need to go through the Department of Health; second, the Department of Labor; third, INS; fourth, the Department of Homeland Security; then the State Department; then the visa is issued." Barboursville is required to pay an "adverse affect wage" of $9.05, presumably for its adverse affect on the local workers. But local workers rarely apply for these jobs, for which Barboursville is required to place advertisements in the newspaper. Fernando says, "First and foremost we have to advertise in the papers and radio that these positions are available. A couple come. They last about a week and then they go."

In Mexico, there is a network of recruiters who know who in the local villages wants to work in the States. Fernando says, "They have to pay quite a bit of money in embassy fees. They borrow the money and then they pay it back once they are here." Fernando buys them an airline ticket and provides them with housing and transportation. They arrive in February and go back in October. One can imagine their bewilderment as they are dropped in the modernity of Dulles Airport from the rural Mexican countryside.

On a wooded lane at the sprawling vineyard is a relatively new modest house that looks like it could belong anywhere in suburbia. Here, a dozen dark-skinned men live and eat together, piling out of a van where they have come to gather for lunch. Each of them has a story to tell.

First is Francisco Martinez. He says, "In Mexico, I was working in agriculture and construction where I was earning $150 every week." He explains that he has two daughters and one son. Since 9/11, Virginia has

Entrance to Barboursville Vineyards, Barboursville, Virginia, established in 1976 and producer of the renowned Octagon red. *All color photographs by Jonathan Timmes.*

Barboursville winemaker and general manager Luca Paschina.

Chrysalis Vineyards, Middleburg, Virginia.

Horton Vineyards, Orange County, Virginia.

The tank room at Horton Vineyards.

Vineyard consultant and longtime viticulturist Chris Hill and Dave Pollak of Pollak Vineyards, Greenwood, Virginia.

Linden Vineyards, Linden, Virginia.

Jim Law, proprietor and winemaker at Linden Vineyards.

The Winery at LaGrange, Prince William County, Virginia.

Chris Pearmund, winemaker and managing partner of the Winery at LaGrange, Prince William County, Virginia.

made it more difficult for foreigners to obtain driver's licenses. So Francisco, like the other workers, has no license but relies on the chauffeur employed by Barboursville, who drives him to the local Mexican market, from where Francisco sends money to his family every week. Francisco works in the vineyard and with the tractor. He first came to Barboursville in 2004. Asked whether he likes wine, he says a little but he prefers beer.

Sitting next to him at the table in the kitchen is his brother, Rogelio Martinez. He says, "I came to Virginia because here there is stable work. In Mexico there is only sporadic work. Here there is a good opportunity to work for seven months." In the Mexican state of Zacatecas, he too worked in construction and on a farm growing corn, potatoes and onions while planting beans and corn for his own family. He explains that some of his friends in Mexico have come to the United States to live as illegal aliens and stay for four or five years because the trip is difficult, dangerous and expensive but while they are here they earn a lot of money. He explains that it costs him $400 each year in fees to obtain a visa to come to the United States.

Jose Luis Arocha is one of the men who was working on the tractor. The other men here are all Mexicans whose dark skin shows their Indian heritage—each of them looks as if he is the offspring of Malinche, the Mayan mistress of the Conquistador Cortez. But with his glasses and Caucasian features, Jose Luis looks like he could be an American college professor, and the other men laugh when this is pointed out by the visiting journalist. Jose Luis is from the north of El Salvador, in an area called Sonsonate. He explains that in Virginia, he learned from Fernando how to take apart the tractor. He works in the vineyard, at the harvest and of course with the machinery. Rural El Salvador must be poorer even than Mexico, for he says that he was working as a driver in agriculture earning $200 per month. He found this job at Barboursville through a friend who used to work here. He does not pay taxes on his wages here in Virginia or in El Salvador. He does not know whether his wages are deducted for social security or other taxes. (They are not.) Fernando says that the workers pay no taxes, including social security taxes, for they are required to go back to Mexico and thus will not receive a retirement pension in the States.

THE THREE COUSINS

Rolling through Fauquier County, a winding mountain road is lined on both sides by rock walls that could be one hundred or more years old. Climb a steep driveway up to a vineyard and a handful of men are snapping off laterals and positioning shoots. Three of these men are cousins.

The three men sit around a table in the winery telling their tale. The winery owner explained that the men are for the most part shy and reluctant to tell their stories, but they warm somewhat to the odd sight of the Spanish-speaking gringo journalist who has placed a tape recorder before them.

Geraldo says that he came from the Mexican state of Chihuahua in part because his sister was already here in Strasburg, Virginia. He first worked pruning apple trees in a Flint Hill orchard. He has a difficult time recalling when he came to Virginia, but when given the reference point of who was president, his memory recovers and he says it was 1988—"more or less." During the harvest, the rank of winery workers swells because extra hands are needed to bring in the grapes, so Geraldo asked around to find out where he could find work picking grapes. He found work at this winery. After the harvest, the owner asked him to stay on full time.

Geraldo and his cousin Guadeloupe came to Virginia prior to the 1987–88 amnesty program and started working at this vineyard full time in 1991. Eloy, the third cousin, came to the United States four years go. Geraldo is a U.S. citizen now, and he is working to bring his wife here after two years of filling out forms—part of the delay is due to the fact that he made a mistake in the procedure and had to start all over, this time with an attorney.

Eloy has been here only four years, having worked all of this time with Geraldo, and he is illegal. It is somewhat surprising that he lives in the wealthy enclave of Middleburg. He says, "A friend in the church helped me get my driver's license using my Mexican identification documents."

Guadeloupe came to Virginia in 1988. He has a wife and one daughter. He says that he sends $700 to Mexico each month and saves $600 for himself. It costs him $12 each time he wires money to Mexico. Guadeloupe does not have a driver's license and says that he has already been stopped by the police one time and is worried about being stopped again.

Guadeloupe pays taxes. He got a work permit and a social security number in 1988. Each year he went to renew his work papers, but the last time he went for renewal the government told him "no." So he went back to Mexico for vacation and to get the other papers that the government was asking for in order to obtain amnesty, but he could not find all the required documents and he also did not understand what else they were asking for. The documents that he did find were lost in the mail that he sent to the U.S. government. So the amnesty date came and passed so Guadeloupe lives in Virginia as an illegal alien.

Geraldo says that the men are happy with their work here. He says, "On this farm we work the hours that we want to depending on the weather. We never work too late. In summer we work ten hours from seven in the

morning until five in the afternoon. In winter eight hours, or five, six, seven, depending on the weather. If there is much rain or snow we work in the winery."

MEXIFORNIA

Victor Davis Hanson is a classicist at California State University and writes often for such publications as the *Wall Street Journal*. He has written several books on agriculture, including *Mexifornia* and *Fields Without Dreams*, a bitter memoir of how his family of fifth-generation farmers lost everything while farming grapes to make raisins. His experience comes from having grown up in the Central Valley of California, where migrant workers have been coming to work for generations and where he was one of the few white children in the public school there. Hanson points to a darker side of the Mexican migrant worker experience, echoing the same refrain as the Mexican poet Octavio Paz. What he says today portends a possible future in Virginia some generations hence. To wit, the Mexican can never really feel at home here, preferring to live life as an internal expatriate, what Paz calls "pachucos." He never really assimilates into the American culture, retaining his language and foregoing citizenship in many cases, always wanting to go back to Mexico. The hardworking Mexican immigrant does not understand why his children, the second generation, do not want to work in the fields and instead prefer to shave their heads, get tattoos or, worse, join street gangs. At twenty and thirty years of age, the Mexican worker "is smiling and fairly skipping" through the vineyard. But at forty and fifty years of age, his bones are old and his demeanor bitter as he ponders the world around him while the employers bypass him for the younger, stronger men. The migrant worker might mow the lawns of the wealthy but never can really become one of those "pink persons in a bathrobe" lounging by the pool while some immigrant vacuums for leaves. On the one hand, America is a better place, for here one is not defined by his parentage or the darkness of his skin as they are in Mexico. Here the gringo owner will chat with you, inquiring about your family, unlike in feudalistic Mexico, where the patron will not even acknowledge your presence. The Mexican migrant worker longs to return home to Mexico but never quite does so, having become trapped between one culture that tolerates him and another, the Mexican culture, to which he can never really return.

THE CANADIAN
WINEMAKER AT TARARA

S tanding in the cellar at Tarara Winery, Jordan Harris opens the valve on
a tank of syrah and the dark purple juice sprays out into a wine glass.
The winemaker swirls the glass, sticks in his nose and takes in the spicy aroma
of this big wine with bold texture, which the winery will sell for fifty dollars
per bottle. The cellar is a chilly forty degrees, so cold that the malolactic
fermentation of the red wines in barrels has stopped midstream, waiting for
warmer weather. The winery here is built below ground, which the textbooks
say will keep the temperature at an even fifty-five degrees, the temperature
of the soil. But what the books fail to mention is that if you open the door of
the cellar and keep it open too long, the winery will cool—without any heat
there is no way to warm it up again. That is what has happened here. So the
wines that are normally evolving in the tank and barrel are not evolving at
all. Like the creatures in the countryside, everything is waiting for spring.

Jordan and his assistant winemaker, Jon Boyle, hail from Canada, which
Americans think of as the land of onerous taxation, where there is de facto
criminalization of tobacco and transfer payments to fishermen who don't fish
and Indians who don't pay taxes. We in the States think that the whole of the
North is frozen tundra and mountain peak, crossed by snowmobile trails and
populated by far-flung Eskimos. When a cold wind blows in, we invariably
call it a "Canadian cold front," as if the country itself were responsible for
our frozen misery. But the fact is that Canada has many times the acres of
vineyards planted as Virginia and New York combined in an area called the
"Niagara escarpment." There, the warm waters of Lake Ontario serve to
protect the vines from subzero weather. Jordan worked there as a winemaker
at a boutique winery and then moved over to the 500,000-case Niagara
Vintners Incorporated. Now he is in Virginia, preferring to work again in

a boutique winery like Tarara rather than an industrial one where one is "making wine by the numbers behind a computer."

Tarara Winery is in the middle of an effort to turn around its reputation and the quality of its wine. With its long frontage along the Potomac River and miles of walkways, nurseries and blackberry patches, it was known for a time more as a place for weddings and parties than award-winning wine. Gone are the festivals, which included face painting, replaced with a viognier festival that pairs the best of Virginia viognier with food from local chefs.

Tarara buys little fruit, preferring to grow most of it itself. While it still grows hybrid grapes, it sells those to home winemakers and other wineries, preferring to focus its efforts entirely on vinifera. Jordan says that the reason for this has nothing to do with the quality of the hybrids. Rather, it is that they are only known regionally, and thus would limit the winery's goal to take Virginia wines international. Jordan says, "Our goal is to become an international winery. As good of a wine you can make with seyval and others, unfortunately they are not internationally recognized grape varieties. They are illegal in the European Union. We don't want to limit ourselves to our own backyard."

Inside the winery, some of the wine tanks containing white wine are coated with a layer of ice as the wine is chilled to thirty degrees Fahrenheit. This is called "cold stabilization," as crystals of tartaric acid form and settle to the bottom of the tank. The winemaker racks them off (separates the solids from the liquid by transferring the liquid from one tank to another) so that when you put this wine in the refrigerator, it does not form crystals. This is merely an aesthetic process and has nothing to do with taste. You can buy these crystals in the grocery store, where they're better known as cream of tartar. (Side note: Cold stabilization will also lower the acidity up to 1 gram per liter in some cases due to fall out, mostly tartaric, and will in turn change the balance of acid in the wine.)

There is consensus that Virginia's best white wine is viognier, but opinions are divided on what red grapes are best for this region. Winemakers outside of the region do not have much experience with viognier, but Jordan knew about this wine prior to his arrival in the Old Dominion, for he spent time in Condrieu, France, where the grape originated. Jordan says, "I drink a lot of Rhône wines." He won a sommelier competition sponsor by Inter-Rhône, which sent him to the Rhône Valley. "I think Virginia viognier stands up quite well to the Condrieu. They are a far better value here in Virginia for viognier. I hear people say the prices of Virginia wines are too expensive. I always shake my idea and wonder what is the thought process behind that." He singles out Chris Pearmund's viognier as an "absolute steal compared to Condrieu, starting at $50, $60 and moving up to $100 per bottle."

Jordan is unique in his thinking about wine and confident in his ability. His technique for making chardonnay is different and at first glance appears risky. He knowingly exposes it to oxygen until it turns the dark color of tea—if an amateur winemaker did this, he would think his wine spoiled. Jordan explains, "The type of soil we have, the type of climate we have, I know that we are not going to be making a flinty-style chardonnay. We just don't have that in our soils. The kind of wine we can make in our vineyard is more of a bigger, juicier, rounder wine." So he lets it oxidize and then the oxidation falls out as the wine ferments. He says, "What you get is a fatter, fuller, richer mouth feel in your wine." You would not do this with a mineral Burgundy wine because in that case the mineral flavor itself would fall out.

The French are the worst when it comes to government oversight of agricultural practices. In Bordeaux and Burgundy, the grape growers are told how many vines to plant per acre and even how to prune their vines. In Spain, a grower needs a permit to plant a new vineyard. Canada, perhaps owing more to the Code Napoleon than English common law, is full of onerous laws as well. Jordan says that the government forbids grapes grown on the top of the Niagara escarpment, where they would be subjected to weather that is too cold. Officials dictate the temperature at which grapes destined for ice wines can be picked and say you cannot produce more than two hundred gallons of wine from a ton of grapes. These rules, like the French ones, are meant to protect the good producers from the bad ones, even though they may appear silly to the outsider. If you are making more than two hundred gallons of wine from a ton of grapes, Jordan says, "You are either adding water or pressing the grapes too hard." In Canada, winemakers are not allowed to add water to wine—a practice that is widespread in California, Chile and other hot climates lest the alcohol get too high—and very hard-pressed grapes make for the lowest quality of wine.

Canada is not the only country replete with ridiculous rules written by bureaucrats who feel compelled to reiterate the obvious. Fermenting wines produce carbon dioxide gas, which if breathed to excess can cause death by asphyxiation. In Burgundy, men strip down to their underwear to punch down grape skins with their bare feet, a practice that is now frowned upon because it can be dangerous. So to keep Jordan and others from climbing into the wine tanks for more than the allowed period of time, OSHA agents made Tarara put up signs that read "Confined Space, Entry Permit Required."

The Champagnes of Virginia and the Woman Winemaker at Veritas

Claude Thibaut cannot call his wine "champagne" because that would raise the ire of the French copyright attorneys. So he calls it "Virginia sparkling wine." Nor can he call the process by which he makes it "methode champenoise"; the same attorneys would say that he can call it the "traditional method." So Claude writes "blanc de chardonnay," which is self-explanatory, for the bottle's classic wide bottom and wired-on cork declares to anyone who sees it that this is champagne.

Tucked away in the bottom of the cavernous Veritas Winery behind row after row of wine barrels, you will find the Thibaut-Jannison winery and its winemaker, Claude Thibaut. Peering from behind eyeglasses, this soft-spoken, rather slight Frenchman looks like he could be an intellectual holding court at a café on the Left Bank. Liberté, fraternité, egalité notwithstanding, Claude is no Jacobin, but a winemaker hard at work making elegant Old World wines here in the New World.

In Champagne, France, winegrowers grow chardonnay, pinot noir and pinot meunier to make champagne. Detractors would say that they make champagne there because the weather is too chilly to ripen grapes and make a proper varietal. But that has changed with global warming; now champagne producers are seeking cooler weather, and equivalent chalk soils have made it possible to plant vineyards in southern England. Thus transferred from its roots on the continent, why not go farther west, to, say, Virginia, to grow this Old World wine?

In Virginia, there is lots of chardonnay. One grower says that it is a weed that will grow anywhere. But pinot noir does not do well in the heat, humidity, rain and drought that is the Virginia climate. So Claude makes his champagne with chardonnay, although he is working with one grower who

is planting pinot noir on a northeast-facing vineyard, where it might escape the worst heat of the day.

Heavy and frequent rain in Virginia is not at all a problem for Claude Thibaut. He says that in northern France it rains all the time, so the growers of such pricey wines as Dom Perignon and Moët et Chandon must pick their fruit early to avoid problems with botrytis and sour rot. The carbon dioxide that gives champagne its bubbling character heightens the taste of the grapes. Flavor in fine wine should be subtle and not overpowering, so the growers pick the grapes at seventeen or eighteen Brix (the concentration of sugar in the wine), whereas for ordinary wine production, a grower would wait until the sugar level reached 21 percent sugar or more.

One of Claude's grape growers is Ivy Creek Vineyards, a vineyard that was originally planted by the Canadian behemoth Seagrams. Ivy Creek plants two clones of chardonnay: clone number 4 from the University of California and one it simply calls "New York." Claude says that both have small berries and small berries give the wine more flavor, since there is more skin in relation to the fruit pulp.

Champagne is made by fermenting the wine twice. Claude starts the process by making an ordinary chardonnay wine. He uses a low foaming yeast and ferments the wine at a warmer temperature than one would normally do to make wine because, he says, "I don't want to extract too much flavor."

Because Virginia is so warm, the acid is low in the grapes already. For this reason, he does not add bacteria to make the wine go through malolactic (ML) fermentation, as they do in Champagne. You do not want an ML fermentation in the bottle because the bacteria would cling to the glass and would produce excess pressure, causing the bottle to burst.

When the wine is dry, it is bottled with a Coca-Cola–style cap. Then some yeast and sugar are added to the wine to cause it to ferment anew. That fermentation takes six to eight weeks at fifty-five degrees. The yeast dies and then collects along the side of the bottle, where you can see it inside. Claude leaves the bottles on their sides for up to two years. The yeast gives the wine texture. At Dom Perignon, they leave the wines like this for more than five years.

At the end of two years, the bottles are put into a riddling machine. In France, the traditional technique has been to put the bottles in a rack and rotate them by hand. But the riddling machine is a labor-saving device. The bottles slowly rotate over several weeks until they are vertical—this is called "sur pointe" in French. Then the neck of the bottle is frozen so that the plug of yeast slides out along with a plug of ice. The cork is wired on by another machine, and a liqueur is added to make a sweet or demi-sweet finish.

The Champagnes of Virginia and the Woman Winemaker at Veritas

Claude says, "Champagne is the only region in France where you can add sugar and acid." The reasoning behind this is that "if you add sugar, then grapes are not ripe enough so you should have enough acid."

Claude also makes sparkling wines for Veritas Vineyards with the winemaker Emily Hodson Pelton, using cabernet franc and chardonnay. Sparkling wine made in this style on the Loire Valley in France, where they grow lots of cabernet franc, is called "Tremont."

The wine that he pours on this day in 2009 is a mixture of two vintages: 2005 and 2006. He says that it has a "baked apple flavor." The wine retails for about twenty-eight dollars.

Claude graduated from the University of Rheims in Champagne, France. He made champagne in California in the 1980s at Iron Horse and then moved back to his native Champagne. He says, "Jeff Jackson [of Kendall Jackson] contacted me in 1999. He said, 'I want to make high-end sparkling wine.'" But the winery did not find a ready market for the wine, so Claude found himself without a job and with a new American bride. He consulted in California until he found work at the Kluge Estate in Virginia. Asked whether he had to take direction from Michelle Roland, the winery consultant working there, he said no because another winemaker was in charge of making red wines there. Claude also has made wine at Champagne Vve Devaux, Bar sur seine, France, and Yarra Bank, Victoria, Australia.

At the other end of the winery Emily Hodson Pelton is tapping away at her computer in the laboratory at her family's winery. Outside the door, she can hardly get to barrels of viognier that she is making. Cases of chardonnay are piled high in this ten-thousand-case winery, for she has just bottled three different styles of them. In a world dominated by men, Emily stands out for her merit. In 2007, she won the Sweepstakes Award for Dessert Wines and the Judges' Choice Award in the Women Winemakers' Challenge portion of the 2007 National Women's Wine Competition.

Emily makes wine at Veritas with her father, Andrew Hodson, who was a neurologist in Florida; consultants Michael Shaps and Claude Thibaut; and her mother, who tends the vineyard, along with consultant Chris Hill, whose telltale ballerina trellised vines line up outside the winery. In a state where most winemakers studied outside the state, Emily graduated with a degree in enology from Virginia Tech, studying with Dr. Zoecklein, the world-famous enologist.

The barrel room at Veritas is lined on both sides with barrels stacked high, including touriga nacional and tannat, which Emily uses to make port. Touriga nacional is readily recognized in the barrel for it has the characteristic liquorish taste that is the taste of port. She says, "The technique that I use is the real old-fashioned port technique. I get the

fermentation started and then stop it at 4 or 5 percent alcohol. Then I add brandy to kill the yeast." The brandy that she uses comes from California. The alcohol laws do not allow Emily to make her own brandy; she would need a separate facility just for that.

The port here is aged for two years before bottling. Emily says, "Tannat is the ink of my port" and is used to give it more color and weight. With the cost of French wine barrels having climbed to $1,100 this year, it is most judicious to use a mix of those and American oak. As for the name, only the Portuguese can call their offering "port," so she calls hers "Othello."

Her father Andrew, with his piercing blue eyes and handsome good looks, is a literary fellow, as one would expect from a well-read Brit. Apparently a fan of Picasso and his paintings of the court jester, Andy calls one of the reserve white wines made here "Harlequin." The story of how this wine was originally designed is a funny one. Andrew racked the viognier into the chardonnay by mistake, and the blend was made by happenstance. The jester is a blend of personalities.

Tasting the viognier from the barrel, one can see that white wine should not be drunk while it is too cold. Emily holds the wine in her hands, warming it up until its nose and flavor of peach become apparent. The wine is made in the tank, at which point the gross lees are tossed out but the lighter lees are transferred with the wine into barrels. Then the wine is stirred and the lees give the wine some texture.

Among the Virginia wineries, Veritas is in the highest echelon. The high quality of the wines is suggested by the elegantly designed label on the bottle. The winery is located in the area south of Crozet near King Family Vineyard, White Hall and Tarara. Therefore, this mountain valley has become sort of a smaller appellation within the Monticello appellation, albeit with no discernable name.

THE LOBBYIST

The Speaker of the House of Virginia has a problem. Rowdy drunks tumble out of a bar in a residential neighborhood in his district, waking up his constituents, who in their ire phone up their congressman, phone up their senator, phone up their governor trying to get the ear of someone who will forever shut down this blight on the neighborhood. The Speaker, in turn, phones up Curtis Coleburn, who is chairman of the state Alcoholic Beverage Control (ABC), to find a way to yank the unruly bar's license. The chairman then informs the Speaker that due to a recent ruling by the courts, there is no longer any legal basis for doing that. So the Speaker tells Curtis to write new legislation to plug this gap in the law. The first draft of the legislation suggests that a "diminution in property values" on an "adjacent property" can be the basis for taking away an establishment's liquor license. An attorney could pick up this statute and argue that the noise emanating from a bar has diminished the property value of the bar's neighbors.

David King, lobbyist for the wineries and owner of King Family Vineyards, senses a threat. He believes that a winery's neighbor could use this statute to shut down a winery by taking away its license to sell alcohol. He says that this would be "open season on the wineries." Wineries in Virginia are popular with people who frequent the tasting rooms and those who would like to see some kind of agriculture take the place of so many apple orchards, vegetable farms, cattle ranches and row crop farms that shut down a generation ago when industrial farming drove so many families out of that business. But not everyone is a fan of the wineries. Chris Pearmund keeps a sign over the door of his winery that reads "beware of attack neighbor," for he has had run-ins with the guy living next door, who complains about the noise and traffic. Kate Marterella is once again feuding with her neighbors, who want

to shut down her winery because, while it is in a rural area, it lies within a neighborhood that has restrictive covenants; the neighbors claim that the noise of vehicle traffic on the gravel drive is too much. Ann Heidig, president of the Virginia Wineries Association, closes her winery on Sunday mornings out of deference to a church that is within eyesight.

In the past, an issue like the Speaker's bill might have caused big problems for wineries, for while they have had representation in the capitol, it was not always full time. This time, David King, chairman of the Legislative Affairs Committee of the Virginia Wineries Association (VWA), is sitting in the meeting rooms of the committee on General Laws when the chairman himself walks by. Consequently, David is able to defuse this threat before it ends up on the governor's desk, signed into law.

Matt Conrad, at twenty-nine years old, is set to take over this year as paid full-time lobbyist for David King as director of the Virginia Wine Council, the umbrella lobbyist association for the VWA. David has been paying out of pocket to be in the capitol almost every day for the past three years during the six-week legislative session. He wants to quit doing that and return to running his winery, which he says finally is turning a profit after ten years in operation. David has also raised money, mainly from seven other wineries and the VWA, to pay for attorney Terri Bern to lobby the legislature, but she has moved on to the Wine Institute to lobby the U.S. Congress on behalf of wineries nationwide.

While in college, Matt Conrad pushed a bill through the legislature that would require that a student be on the board of visitors for area universities. Matt says that lobbyists in generally have a bad reputation because of all the negative publicity coming from the U.S. Capitol. He feels "as if he is one of the good guys in white hats" lobbying for family farms and small businesses. Before the day is over, he has convinced Senator Obenshain to pull a bill that would privatize the state-run ABC stores. Mark Obenshain is a friend to the wineries but does not realize that the State of Virginia would then have to turn over Virginia Distribution Company—a state-run entity used by small wineries to distribute their wines—to private ownership, which would be its demise.

Here in the General Assembly, as the process of legislation unfolds, it looks just like "horse trading," which is how lobbying is often described. In the state capital of the New South, vestiges of the Old South are right outside with statues of Stonewall Jackson and Robert E. Lee down on Monument Boulevard and Jefferson Davis's White House of the Confederacy just around the corner. The members of the committee themselves look like something out of a novel by William Faulkner. Thomas Gear, who is a fan of Horton Vineyard's norton wine, with his sweeping Blagojevich mane of hair, looks

Left: Among those pictured are Al Weed, Pat Reeder, the secretary of agriculture and C.J. Reeder. *Courtesy of Pat Reeder, Burnley Vineyards.*

Below: Governor's Wine Grape Advisors Board with Governor George Allen. *Courtesy of Pat Reeder, Burnley Vineyards.*

like a mountain man from West Virginia. Leaning forward in his chair, Glen Oder, delegate from Newport News, has huge bushy eyebrows that make him look like the scion of some old-moneyed family. And the youthful committee chairman, Chris Jones, with his sly grin and friendly demeanor, looks as if he could be presiding over a Kappa Alpha fraternity meeting instead of the machinations of government.

But the Old South has long been swept away, as blacks and women equal whites in numbers here. Lobbyists and delegates mill about, tapping into their Blackberries even as a sign on the wall admonishes them to "turn off all cell phones and pagers when the committee is in session." Standing in the middle of all this, leaning over the rail to talk to delegates, David King works the floor.

David is a plainspoken former lawyer from Houston who was asked to take over the legislative affairs of the Virginia wineries when legislative issues came tumbling down on the wineries and they perceived disharmony in the ranks. David talks in anecdotes that make the lucid appear clear. Words roll off his tongue in the smooth cadence of the courtroom attorney Clarence Darrow. People and political skills are what are needed here. David emphasizes that what is needed is "boots on the ground," meaning, "if you are not physically in the room when the decisions are made you are not in the game."

Donna Johnson is the chief lobbyist for the Virginia Agribusiness Council. David leans against a chair while Donna flips through a thick notebook, Curtis looking on. They discuss how to change the bill so that it would not affect the wineries. After a back and forth discussion, they huddle again a couple of hours later in the same committee room. Tom Lisk, who lobbies for the hospitality and tourism industry, steps in, and the "adjacent property" and "diminution of value" clauses are stricken from the bill. Fait accompli. "Boots on the ground."

The Winemakers' Roundtable

The roundtable is for professional winemakers in Northern Virginia. What started out as a small group has swelled to thirty people or more who could scarcely fit into the barrel room at Pearmund Cellars. There is a similar group near Charlottesville for the winemakers in the Monticello appellation. The winemakers gather each month to share ideas and talk with their peers about the technical merits of the wines they are making.

Jim Law of Linden Vineyards organizes the meetings, with Doug Fabbioli and Chris Pearmund taking turns serving as senior moderators for the group. On this day, Jason Murray of Chateau O'Brien led the discussion. Jason is well known to area grape growers and winemakers, having been the horticulture extension agent for Loudoun County for many years, specializing in sustainable agriculture. Now he has made his mark here as a winemaker. Jason is one of the younger winemakers, as evidenced by his youthful good looks. He wears his long hair in a ponytail, which looks good, unlike so many other men with long hair who treat their hair as a man would—i.e., they do nothing to it so it looks ragged.

Jim Law of Linden Vineyards did not come, as he usually does, but instead sent his protégé, Josh Grainer, who usually comes as well. Something important must have detained him, for Jim is a senior founding member of this group, and newer winemakers listen eagerly to his opinions. Jim's reputation among Virginia wine buyers is such that he hardly advertises his wines, does not take part in competitions and need not participate in festivals or hold events to attract the customers who have turned what he once called his "hardscrabble" vineyard to what he now jokingly refers to as "pay dirt." Josh is one of his "wine growers." Jim prefers to call them that rather than winemaker or grape grower, insisting that one must do both jobs in order to

make the best possible wine.

Doug Fabbioli sat in the center of the table as if holding court. He is another of the original founding members of this group, having served as manager at Tarara Vineyards, having helped lots of wineries get started by serving as their eyes-on consultant and now having his own winery in the basement of his house in Loudoun County. Doug is known for his work with red wines, including the French hybrid chambourcin, which if not handled correctly can taste like a labrusca American native wine. He also grows his own raspberries, which he blends to make, you guessed it, "raspberry merlot." Doug is thus a *garagiste*, as the French would call him, producing wonderful quality from rather modest facilities, sort of like the Screaming Eagle winery, whose California cabernets sell for hundreds of dollars. In Virginia, wineries don't command prices all out of proportion to quality, as the winemakers here are trying to push prices in the other direction to counter the criticism that Virginia wines are often too expensive.

Doug, in the discourse of diplomatic politesse, deferred to Chris Pearmund when the topic swung to chardonnay. In Virginia, winemakers share their secrets rather than hide them, seeing themselves as allies in the effort to grow the industry. But, obviously, there is friendly rivalry between wineries. One is impressed that such a confined place as a barrel room can contain such large egos. After all, in the winemaking industry, the winemakers' personalities and preferences are personally etched onto the bottles of wine they have created with their hands.

We can, for example, tease Chris Pearmund a bit. Some people are handsome, but former fashion model Chris Pearmund is simply good-looking. He drives a Maserati, which is not a display of ostentatious wealth, since it is a used car. His last car was a used Aston Martin—perhaps it had a martini mixer or Walther PPK when he sold it. One would say that during the course of his workday, Chris is surrounded by admirers. It would thus be easy to become enamored of yourself when, several nights per week, you host winemaker dinners where wine lovers hang on your every word and tipsy women look you in the eye as they worship at the house of Pearmund. But Chris hangs onto his humility and, like the other winemakers here, keeps none of his techniques secret from the group.

Curtis Vincent, the winemaker from Chrysalis, made his usual jovial appearance. In order to work for the owner of Chrysalis Vineyards, Jenni McCloud, one would need to be outgoing and confident, with a thick hide in order to hold his own in debate with someone whose grasp of technical details can be intimidating to others. So it is with Curtis, who came to the winery dressed in his usual multicolored rainbow of tie-dyed sweat pants and bandana. He exudes confidence, so perhaps he will have a long reign

at the winery where other, more timid souls have not lasted long. Jenni calls her winery an "agricultural enterprise" with a winery, creamery and nursery where she propagates norton vines for other wineries. Her vineyard is located in the ultra-wealthy Middleburg section of Loudoun County where horses live in barns fancier than houses elsewhere, behind stone walls erected hundreds of years ago by slaves or, more recently, by migrant workers.

The way the roundtable works is winemakers bring their wines and the winemakers taste them in flights. This is not a blind tasting. Today's topic is fermentation trials, so wines from the recent harvest, some of which were still fermenting, are grouped by winery and varietal. The winemakers solicit opinions as to which yeast or other technique (trial) works best for them or, in the case of problem wines, asking other winemakers how to fix the problem. There is little room for error when one is making wine for profit. A barrel of wine costs about $5,000 and a tank of wine costs much more than that.

The first two white wines we tasted were a sauvignon blanc and a seyval, which is a French hybrid. The winemaker was worried about the hair spray aroma in one and the peanut butter flavor in another. Their peers agreed that these were the early indications of sulfide problems, the worst of which can turn into the rotten egg taste of hydrogen sulfide. Copper can be used to treat this. If you don't believe me, drop a penny into a wine with sulfide problems—the off aromas will go away. Other wines presented that day with problems just needed time in the barrel or tank or needed to have the lees stirred in the barrel to precipitate some of the early off aromas and flavors that would fall out of the mature wine.

The next flight was a temperature trial of four different clones of cabernet franc all fermented with native yeast at different temperatures. To ferment with native yeast means to use yeast that occurs naturally in your vineyard and winery building, having built up over the years as you make wine, thus releasing billions of them into the air. Most winemakers kill native yeast with sulfur before they add cultured yeast. Cultured yeast are collected from the ancient vineyards and wineries of France and Italy and then grown in a lab and freeze-dried. Working with native yeast can be tricky, as they can get stuck before fermentation is complete, leaving you with a tank full of grape juice that cannot be called wine. I once flew to Chile with 50 kilograms (110 pounds) of yeast stuffed into my luggage and the package burst open en route. So when I arrived, all my clothes smelled like bread. The four wines fermented here were fermented at different temperatures. White wines are fermented cold (from fifty to seventy-five degrees) to preserve their aroma and flavor. But with red wines, it's all about structure and finish. Red wines are fermented hot (from seventy to ninety-five degrees) so the aroma and flavor, which are volatile compounds, tend to blow off with the carbon dioxide

exhaled by the fermented wines. These four wines ranged from jammy to what the winemaker described as "cooked," although the cooked one was the favorite picked by the others.

The best sauvignon blanc wines are those that have a grassy herbaceous aroma and a little bit of viscosity, like the New Zealand ones from Marlborough. Of the next two sauvignon blancs offered up, it was hard to pick between the first one, with that grassy herbaceous flavor, and the second one, which had the mineral overtones claimed by the best gewürztraminers of Alsace or the most expensive chardonnays of Burgundy. Here you could see that the selection of yeast does have a definite impact on the finished product, since otherwise the wines were made the same and the fruit had come from the same vineyard. Chris Pearmund commented that banana flavors often come from white wines fermented at very cold temperatures.

The roundtable is an opportunity for the growing Virginia wine industry to polish the skills of its winemakers by sharing knowledge and critiquing one another's wines. It is in the spirit of cooperation that most wineries attend.

THE WILLIAMSBURG WINERY

Patrick Duffeler of the Williamsburg Winery looks like a European count. His pale skin is almost translucent and he has an aristocratic manner, unfurling his hands as he speaks. Born in Brussels and educated in New York State, this native French speaker spent much of his career in Switzerland working as the European marketing director for Philip Morris and as an executive with a Swiss investment company with interests in Burgundy. His parents were Burgundy and Bordeaux wine drinkers who took him to visit most of the castles in Europe, from Norway to Portugal, thus instilling in him a love of history. Heading to Virginia with "the two boys, the au pair [and] the two dogs," he relocated to an abandoned farm in Williamsburg, where, in 1983, he planted his vineyard and began to build what is the largest winery in Virginia today.

Outside his office located on the top floor of the winery, row after row of vines have broken bud a full three weeks ahead of the vineyards in the western part of the start in this chilly start to the growing season of 2009. The temperature here is moderated by the James and York Rivers, which Patrick says "are massive bodies of water and therefore they stabilize our weather." While the weather might be milder here than elsewhere in the state, the birds are evidently more voracious, for each vineyard row includes permanent bird netting that is unfurled as the fruit begins to ripen.

Patrick walks through the porch of the Gabriel Archer Tavern on the winery grounds, greeting guests as he arranges lunch for the visiting journalist over a bottle of Acte 12 chardonnay, which, he points out, has been mentioned in *Decanter* magazine. Most of the guests recognize him, having seen a video of the winery shown in the tasting room. The large winery building itself is constructed in the colonial style, overflowing its capacity with wine tanks

The Williamsburg Winery and Wedmore Place, 2008. *Courtesy of the Williamsburg Winery and Wedmore Place.*

Patrick Duffeler, 1987. *Courtesy of the Williamsburg Winery and Wedmore Place.*

standing outside as they do in Chile and elsewhere. Beyond the winery is a twenty-eight-room hotel that looks as if it had been lifted from Provence or medieval Beaune.

Patrick runs the winery, restaurant and hotel with the help of his son, Patrick II, who has the look of his father, albeit with a red blush indicative of his youth. The staff keep the two men apart by calling them "P1" and "P2." Everything here is done on a grand scale, for Patrick, an economist by training, believes that a winery must have a "critical mass" in order to survive and prosper. Having ordered still more grapevines for another expansion, he has invested more than $1 million in the last five years replanting his vineyard. He says that he founded his winery with the following goal: "From day one, with ultimate target of topping 100,000 cases because I believe there is an issue of critical mass which I think is very important." As the business ramped up, he got into the business of importing wine from foreign countries to justify his large sales staff and build a distribution network. Today, you can see his wines in most Virginia grocery stores, shops in Manhattan and in fourteen other states.

As a businessman, Patrick is firm in his assessment about what needs to be done to push the Virginia wine industry into the next tier. While calling relations within the industry "collegial," he directs criticism at the state's

Williamsburg Winery, 1990. *Courtesy of the Williamsburg Winery and Wedmore Place.*

Williamsburg Winery, 2000. *Courtesy of the Williamsburg Winery and Wedmore Place.*

dominant organization: the Virginia Wineries Association (VWA), from which he resigned as president. Patrick puts great hope in the new Virginia Wine Council and Quality Alliance for Virginia, which is in the planning stages. There are similar organizations in Washington, Oregon and New York that have done much to promote those states' wines, build credibility with the world's wine critics, quell discord among industry players and impose some kind of quality standards and strategic thinking. Patrick's other point is that grape prices need to come down and volume go up in a state that is dominated by boutique wineries and the tourist trade if the state hopes to compete with Chile, Argentina, France and Italian wineries around the world.

Patrick was president of the VWA for five years and has sat on the Governor's Wine Board for most of its existence. He echoes the same criticism of the VWA as some other members, many of whom have dropped out of the VWA, leaving the organization somewhat fractured. He says, "Virginia from a wine industry point of view has not gotten its act together. I regret it, but that's just the way it is, which is one of the reasons I have not been involved in the VWA for the last four or five years. They became too parochial. There were divisions in the industry."

Continuing, he says, "I read the book of *Napa: An American Eden*. And what's happening in Virginia is exactly what happened in Napa a few years back, decades ago actually. [There are] issues of dealing with the legislature. Issues of dealing with counties. Issues of some of the people who want to be more conservative. Some of the people who want to say, 'Oh! You're in Napa. You need to be 100 percent Napa grapes.' Those same issues come up in Virginia."

Much progress has been made in the VWA with regard to legislative issues, with David King, owner of King Family Vineyards, stepping up to take over the lobbying function. The industry has also hired a full-time lobbyist, Matt Conrad (see chapter "The Lobbyist"), to head up the newly erected Virginia Wine Council. But there is still discord and division over issues such as quality standards and relations with the Virginia Vineyards Association. Patrick would like to see the Virginia Wine Council operate as it does in New York under Jim Tresize, a personal friend of Patrick's, whom he says has done much to promote New York wines and wineries to obtain funding from the state for marketing and research. Some winery and vineyard owners would like to see Virginia adopt quality standards as in Washington, Oregon and Ontario. These would allow a winery to apply a label on the bottle that reads "Quality Alliance for Virginia." This would appease, for example, grape growers who put forth a motion this year at their annual convention that the wineries adopt a label that would designate the wine as from 95

percent or 100 percent Virginia-grown fruit. (The Williamsburg Winery is both a farm winery and a commercial winery, which means that it operates in two markets. As a farm winery, it makes Virginia-grown wines whose label says "Virginia." As a commercial winery, it makes wine from grapes sourced from Virginia and elsewhere whose label says "America." Patrick says that industry friends once accused him in jest of "vacuuming up all the grapes" on the eastern seaboard.)

Of the quality alliance, Patrick says,

> *I was at the state board where we discussed that very topic, the issue of the quality alliance concept here, the issue of having a wine council. We are going to get there. There has been a bit of parochial thinking among some members of the industry that has not been geared adequately to the realities. At this particular point, I am considering going back to the VWA or the Wine Council. A lot of wineries dropped out. I want things to be done with a certain formality, a certain strategy, a certain plan and be guided by written-down policies and agreed-upon procedures. If you don't do it that way the byproduct becomes amateur work.*

His second concern is that the industry has not achieved what he calls "critical mass" because too many boutique wineries are planting too few grapes that sell at too high a price. He would like another 100,000-case winery to open its doors here, saying of the investment climate, "A vibrant industry can attract investors to the industry." Seagrams and a large French company, for two examples, have started wineries in the state only to pull out later.

He worries that too many wineries have spent too much money on their buildings and facilities while not planting enough grapes. He says, "There are wineries which have accumulated significant presentation costs, in other words beautiful buildings, millions and millions for a building, and they have a plan for doing five thousand cases. I worry about the structural aspect of that. Any business has to at some point reach a critical mass to pay for its investment."

He continues, "Virginia has demonstrated that we can make terrific wines and we can market terrific wines. But we still have to demonstrate that viticulture is economically sound in Virginia. That is the next challenge we have to face. We have some terrific grapes that cost [a lot of] money on a comparative basis. I am concerned there are too many vineyards which are very small in Virginia which cannot be very profitable."

He acknowledges that most wineries sell most of what they make right in the tasting room without eyeing the global market, i.e., the grocer's shelf, but

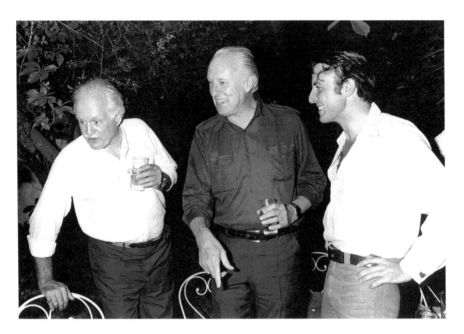

Patrick Duffeler with Baron Toulo de Graffenried and Prince Paul von Metternich, 1977. *Courtesy of the Williamsburg Winery and Wedmore Place.*

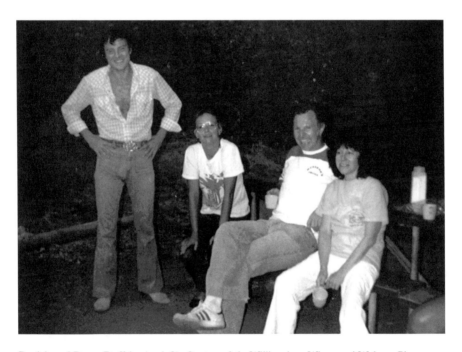

Patrick and Peggy Duffeler (on left). *Courtesy of the Williamsburg Winery and Wedmore Place.*

he questions their fiscal viability. He dislikes the word "globalization" but says that Virginia wineries need to recognize that the competition is France, Argentina, Italy and Chile, whose ordinary table wine sells for $7 to $12 a bottle. The problem here in Virginia is that a small winery with a five-acre vineyard costs about $1,800 per ton of grapes to farm. Robert Mondavi used to say that the price of a bottle of wine should be 1/100th of the price per ton for grapes. That observation is still for the most part true, with Napa cabernet costing $4,000 per ton and the resulting wine costing $40 (or more) and Virginia wines averaging around $18 to $24 per bottle. Patrick says of that $1,800 production cost, "That's okay if you are only producing ultra premium wine. We need more vineyards producing grapes at $600 to $1000 per ton." In Virginia, hybrid grapes like seyval and vidal blanc sell for $600 to $900, while vinifera like chardonnay and viognier sell from $1,200 to $2,000 per ton. Patrick says, "The key question is you have the adequate amount at the right level." That way, "One can make an easy to drink wine which is well received by the consumer."

The Grape Growers' Conference

At the annual Virginia Vineyards Association Meeting, growers and winemakers discussed merlot and chardonnay farming.

Merlot Panel

Shepherd Rouse

Shepherd Rouse, owner of Rockbridge Vineyard, is a longtime grape grower in Virginia, although of merlot he says, "I don't grow it. It's an early-budding variety so it puts a premium on vineyard site."

He says that in the 1980s and 1990s, we had "five winters that were pretty deleterious to a lot of vinifera with temperatures below negative five degrees. In '96, we probably had the coldest cold I had ever heard of. It was negative twenty degrees at Rapidan and Scottsville."

"At Redlands Vineyard in Southern Albemarle, if I did not pick the fruit by early September, we had high pH problems. Hurricane Dennis and Hurricane Floyd [in 1999] turned what look like a great vintage into not such a great vintage."

Stephen Barnard

Stephen Barnard, a native of South Africa, is the winemaker at Keswick Vineyards. He has twice won the Governor's Cup. His microbiologist fiancée is the daughter of the owner of the vineyard.

Of the 42-acre vineyard, 1.2 acres are merlot. He characterizes it as a blending grape, saying, "In Virginia, merlot is a tough sell as a varietal."

He crops merlot of 3 to 3.54 tons per acre. In 2008, he says,

We did not get the sugars. It started raining. We tried to get to 22.5 [Brix]. *All we ended up doing was dropping the acid out.*

Fruit is chilled. No SO2 added at crusher. Cold soak two to three days or two to three months. 2002 to 2007 have made completely different vintages. Trying to learn what Virginia is all about. Add tons of enzymes, tannin and acid. Last year we had very green seeds and very bitter skins. Did not get physiological ripeness. I would rather pick clean fruit over numbers. We test nitrogen. Add DAP and FermaidK. We have had H2S and sluggish fermentation problems in the past. Cold soak. D245 is the workhorse yeast. Try not to exceed ninety degrees cap temperature. We don't let it grow dry. We pressed off at four Brix. Allowed fermentation to finish in barrel to avoid green tannins. Don't add any bacteria ML. All natural.

Make blending decision in August time. Take care of the vineyard. Wine is on a year-by-year basis. [Merlot is] *such a small production we can afford to experiment.*

ANDY REAGAN

Andy Regan has been the winemaker at Jefferson Vineyards since 2005. He says, "In 2007, frost and the deer did most of our shoot thinning for us." At Jefferson, they have several different blocks of merlot. One is ten years old, one is five years old and one, which Gabriele Rausse planted, is twenty-eight years old.

He says his site is not vigorous producing, 2 to 2.5 tons of fruit per acre. The biggest pest problems are climbing cut worms and Japanese beetles. Twice a year, Charlie Thorton comes out to do a petiole analysis. Andy says, "This past September we got thirty inches of rain from tropical storms." He cautions growers not to "pick at the first sight of rain."

He made a mistake sampling his grapes last year and one block got to thirty-two Brix. So he says, half in jest, "Anyone want some bulk merlot at 18 percent alcohol, talk to me afterward."

"Did seven hundred cases in 2007, winds up being about 30 percent of our meritage blend. I know the flavors that I want are going to be there at the higher Brix. Appearance of stem is important." He says if the stem is dead, it is not going to further ripen the fruit.

"Cold soak. Use a slew of different yeasts to get different flavors. Ferment at high temperature. Inoculate with ML bacteria. Yeast fining seems to add a lot of depth to wines. That was recommended by Bruce [an enologist at Virginia Tech]."

DAVE COLLINS

Dave Collins at Breaux Vineyards farms a large vineyard at 102 acres. He says, "Last year we harvested 400 tons, 150 tons for ourselves and 250 for other wineries." He has been growing grapes since 1985 and worked at Willowcroft prior to coming to Breaux. He says, "At that time was only winery in Loudoun County and on the weekends we never had any visitors. Now twenty-something wineries there."

> We currently have eighteen acres of merlot. Six put in last yeast. All of those on thirty-six-inch lyre seven by twelve [spacing]. Have since gone to close VSP spacing. Have really good soils in western Loudoun. Parent material is granite. Have solid drainage. In western Loudoun, we don't see any puddling. We are dry farmed.
>
> It's a divided canopy so you have to get in there. We have a large staff of vineyard employees. We get people in the middle of the lyre working. We have learned we have to keep those canopies open. To me it [merlot] is not the easiest variety to grow on VSP because it tends to flop down. So guys weave it between catch wires.

He continues, "Keeping canopy open is important. If you get powdery early you are fighting it all year." One-bud pruning is a technique he learned from Lucie Morton, the viticulturist. He says with that the basal bud will come up and be fruitful. "All of our vinifera we prune to one bud. We don't have time on one hundred acres to come back to shoot thin. Our shoot density is four to five shoots per foot. We crop our fruit high. On merlot we struggle to get our fruit below six tons per acre. Sometimes eight tons per acre. When I see one to two lugs per vine I think 'Holy Mackerel, I hope our customers don't see this.'" But he adds that, given the high prices for his fruit, his customers know that the fruit quality is high.

CHARDONNAY PANEL

TOM KELLY

Tom Kelly is the vineyard manager at Rappahannock Cellars. He is talking about the Chappelle Charlemagne Vineyard that the winery leases.

> This is one of three sites that we source fruit from. It is four acres, half of which is chardonnay. We took it over in 2004. It had been neglected. The vines are on six by ten spacing. The chardonnay is clone four on 101-14 VSP. [The vines are on a] southeast to northwest orientation. [We do] four to

six shoots per foot cordon thinning. Just after we bloom pull leaves on both sides [of the canopy]. *Hedge two or sometimes three times per season.* [The vineyard is] *too steep for machinery, so everything is done by hand.* [We] *apply nutrients based on soil and petiole analysis.* [The vines] *yield from 2.25 to 2.5 tones per acre.* [At that site we] *have some winter bud mortality and spring bud damage, which does my thinning for me. I would like to get yield up to three tons as we fill out the trellis area.*

The third week of September is when we harvest. Jason [the winemaker] *and I decide.* [The vines] *hit wall of sugar accumulation at the second week* [in September]. *We have problems with birds in that vineyard so doing netting. It works very well. Also use bird guard* [noisemaking device]. *In 2005, we put up a seven-foot deer fence.*

There is forty-something inches of rainfall every year here. We typically have small amount of late season powdery mildew. Will be trapping grape root borers this year. We became quite painfully aware of presence [of grape root borers] *in our vineyard.*

Being remote, [this vineyard is] *more expensive to farm than estate vineyard. With lower yields that makes for some expensive fruit. Intense lemon drop flavor of fruit. Trying to figure out how to capture that.*

JASON BURRUS

Jason Burrus is the winemaker at Rappahannock Cellars.

First fruit came off it [Chappelle Charlemagne vineyard] *2005.* [This was] *my first vintage at Rappahannock Cellars in 2006. Very unique character is very pleasant lemon drop flavor in the upper vineyard. I have not experienced that before. Thought that would show well in stainless steel. Beginning in 2007 started making it in steel. This is by a large margin our number one wine at the winery.*

I don't care about numbers when I look at fruit for harvest, I just look at how the grapes taste. As a result of that I push the envelope when it comes to pH. I am not shy at all about harvesting at high pH. pH has not been below 3.64 but going by French model that is high, but we don't sell French wine in Virginia.

Nothing we have done to this wine except racking it off its lees. So really is a Chappelle Charlemagne. One thing that Tom does in the vineyard is the grapes are netted. That lets us hang the grape in the vineyard longer.

Animated, Jason stresses that "there is no such thing as native inoculation. Regardless of how you cleaned that tank, last yeast you used is still in there."

He counsels winemakers, too. "Just pick yeast that is lowest producer of H2S because it is in all wines." Recognizing this, he says that he "adds one milligram per liter of copper post rack. It's better to get rid of it sooner or later. You oxidize it to something which is less offensive as you cannot blow if off later."

ROCK STEPHENS

Rock Stephens is known for his meticulous attention to detail. At his Eastern Shore vineyard, surrounded on three sides by salt water, he measures everything and plots the results on a graph, for which he has data going back many years. To understand his craft completely, he does not just farm grapes and leave them to the winemaker to contemplate. Rather, he makes a couple of barrels of wine every year and enters amateur competitions. He has won a gold medal at the Indianapolis Wine Competition.

Rock says,

> I am a grower; we are not a winery. We primarily grow chardonnay and merlot and we would do a barrel of each to see how the wines turn out.
>
> We do have a true maritime climate. Atlantic Ocean to east and Chesapeake Bay to the west. Called it "Point Breeze" because it is breezy most of the time. That has advantages for disease control.
>
> [We have] twenty-five acres. Planted first acre in 1999. Twelve feet above sea level. Good soil that drains well. Surrounded by water. Sometimes spray at night when conditions are optimal. Though partly to thank neighbors for listening to bird machines and cannons.

His grape vines are on 3309 rootstock. He says, "We are pulling out SO2 because we do not like how it handles rain." The vines are grown on a divided open lyre trellis, so named because it is shaped like a musical instrument of the same name. He hedges vines once or twice per year to cut off excess growth. Rock says, "We usually harvest merlot on September 28."

He grows merlot clones #3 and #181. He says that the #181 ripens a few days earlier than #3. The vineyard has irrigation. He says, "Sometimes we will water after véraison if it is extremely hot and the plants are shutting down. Usually we are harvesting a couple of weeks before other growers on the shore because they do not have irrigation."

Rock has solar-powered weather stations throughout his vineyard, which monitor weather conditions, soil moisture and leaf wetness and transmit the results to a base station. He says the leaf wetness indicator shows that there is evening dew even when you are not getting rain. This is important for the spray program. Of that he says, "We don't get downy or powdery

mildew on merlot. In chardonnay, we get powdery mildew every year when in pre-harvest interval [the period of time when you are no longer allowed to spray]. As we get close to harvest, we spray Armicard, which is pretty much baking soda. Some people spray with two inches of rain with sticker spreader or one inch without."

Of his vineyard lessons learned, he says, "Have irrigation." Continuing, he says, "Our number one problem was nursery stock having virus and crown gall. We have to replace a couple of hundred vines every year for one reason or another. Put boron and zinc in with the first sprays to make sure there are no problems with fruit set." He says to use a "tower sprayer, which is important because it sprays down and not up," thus reaching the tops of the vines.

Rock tracks temperature growing degree days (GDD). He says at around 485 GDD, put out grape berry moth traps. He uses GDD to estimate harvest date based on the previous years' data.

JIM LAW

The best way to interview Jim Law is just to listen to what he says and copy it down, since he is such an encyclopedia of information. Here he is talking about how he farms and makes his chardonnay:

> *I don't like electronics at all. I am very much a traditionalist. I think it's more important that you understand philosophies. I've been farming the same place now for almost twenty-five years. Chardonnay is one of the first vines we planted in 1985. I made some mistakes early on.* [Now I am] *trying to weigh pulling out my mistakes or keep the old vines. For chardonnay,* [I am] *keeping the old vines.*

He farms eight hundred vines per acre, with a new planting at two thousand vines per acre. Jim switched from spur to cane pruning. He says, "That means canes have to be long and that presents a problem with apical dominance. So I split the trunks apart so that canes don't have to be as long. I don't see trunk problems we used to have after switching to cane pruning."

> *Leave two buds per foot of canopy space. On a six-foot wire there is only twelve shoots. Still we have to do a lot of crop thinning even with that number of shoots. We grow clone 4, which has large clusters. We have to spend a lot of our labor thinning down the crop.*
>
> [Chardonnay is] *highly susceptible to powdery mildew and botrytis so get leaves off. At bloom go through and pull off leaves on east and north side.*

It looks awful but it works. Get spray penetration. Greatly reduced botrytis and sour rot. Never had much problem with powdery mildew.

Acidity is the most important thing. I am doing everything I can to keep clusters cool so keep shade on western side. In late August, if it is cool, we will start stripping leaves on west side of the canopy. On reds I hedge fairly severely. But chardonnay I let them go. We get a lot of shoots falling over. One reason is I want shade and a bigger canopy. With younger leaves it gives me more aromatics while keeping acidity high.

We do shoot thinning. We pull off tiny little developing clusters when it is obvious it is too much. We come back again in July and fine tune. The interns weigh the clusters.

Chardonnay is the indicative plant for PM. We use a lot of sulfur. We no longer use strobies (expensive systemic fungicides) at all. I consider them to be no longer useful in our vineyard. We did overuse them when they first came out.

Jim has grapevine yellow, which is a problem in his vineyard, and he pulls out 1 percent of the vines each year due to this viral problem. He says,

We use Endure for powdery mold and botrytis.

Grape root borer [an insect that slowly kills vines by eating the roots] *we definitely have. Only way to know is pull up vines, which we have done. Sour rot problems in some years we don't see pure botrytis rot. Not devastating to yield but for quality. That is why we have a sorting table.*

We do compost additions. Have crabgrass as cover crop. You can actually buy crabgrass seed. It does not start growing until late June so it is perfect. It grows low. It mats down. It does not grow in the spring but it grows when you need it.

I don't consider myself a chardonnay producer. I consider myself a Hardscrabble or Avenius chardonnay producer [these are the names of two of his vineyards]. *That is very Burgundian* [outlook]. *What makes me pick my chardonnay is acidity. I am talking about my perception of what acidity is in the juice. I call it the acid ripeness. Green apple acidity it will show up in the wine later as a hardness. I pick based on my perception of the ripeness of the acidity.*

We chilled the grapes to forty degrees. In 2007, there was nothing to sort [because the fruit was so clean]. *In 2008, there was a lot more sorting to do. We are almost always sorting for sour rot. We do crush and destem. Prefer to crush because we get more aromatics and depth. The press wine goes into regular chardonnay not the Hardscrabble. Add 20 to 40 ppm SO2 then settle in stainless steel tanks. Look at turbidity* [a measure of clarity]. *I like it to*

be somewhat cloudy. Then move to barrel after pumping to another tank first [to mix it all the same].

Do 40 percent un-inoculated fermentation. They have a mind of their own. They sometimes go through ML even if you do not want them to. For other barrels, use a lot of different yeasts for complexity. Use all French oak but only 20 percent new. Native fermentations go up to three months or longer. Others block ML for acidity. Lees management is one of the most important parts of our chardonnay production. Stir fairly frequently. 2006 was a little bit meager in the mid palate. Stirring makes the wine meatier. Need to have healthy lees that are not reductive [i.e., oxygen deprived]. *Keep SO2 low because lees help protect the wine. The goal is to have very long-lived wines.*

Tasting his Hardscrabble 2006, Jim says,

I just released this. I love Burgundies. I consume copious amounts for educational reasons. They don't get interesting until about ten years. We held back 1999 vintage and rereleased it. Like slightly reductive style. Feels hydrogen sulfide evolves and gives the wine more depth. The problem with chardonnay is it can be really boring. Yet some of the most exciting wines in the world are from chardonnay. Through the '90s, I made big, buttery chardonnays but did not take it home to drink because I don't like it. Customers used to drinking forty- and fifty-dollar burgundies like this high acidity.

THE WINE LABORATORY
AT VIRGINIA TECH

D r. Bruce Zoecklein sits in his corner office on the first floor of the food
and science building on the campus of Virginia Tech at Blacksburg.
His desk is piled high with enology journals—many of which he sits on the
editorial board of—from France, South Africa, the United States and New
Zealand. Outside his office are two fully equipped wine laboratories and a
working research winery.

Dr. Zoecklein is fired up, offering constructive criticism of the wine industry,
of which he sits as its figurative leader, together with Dr. Tony Wolf, the
state's viticulturist. Dr. Zoecklein speaks in long, complete sentences, using
analogies from geometry to make his points. His command of chemistry is
legendary and complete. Some of his writings can be difficult for the laymen
to follow: quickly, can you explain why fruit pH and acidity are not always
positively correlated?

Lured to the state in part when Seagrams planted the Ivy Creek Vineyard
here in the early 1980s, Dr. Zoecklein has worked in Virginia since 1985,
authored two books on wine laboratory analysis and taught enology as a
professor at Fresno State in California. When the national press and persons
seeking business with the state's wine industry want an opinion, want to
arrange a comparative tasting or are seeking some kind of endorsement,
they usually ring up Dr. Zoecklein.

Virginia winemakers worship Dr. Zoecklein, for he has a wide following
and clientele not just here in Virginia but around the world as well. His
enological newsletter *Enology Notes* is widely distributed. From his frequent
travels around the wine-growing regions of the world, he knows well that
there is a worldwide glut of wine and Virginia needs to change course if it
is to garner the attention of the wine critics and stand out from the other

emerging wine regions. He says his role here is "not to pump up egos," and he is blunt with his assessments.

Dr. Zoecklein says, "I would like to think that this industry has outgrown something so provincial as the Virginia Governor's Cup." He says that it makes no sense to compare Virginia wines with other Virginia wines if the goal is to increase sales and grab the attention of the wine critics. Dr. Zoecklein believes that the only opinion that matters is that of the Dan Bergers, Doug Frosts, Michael Broadbents and Robert Parkers of the world. He says of Virginia wines, "We are competing with wines that are in 7-11 and all over the place and they are frequently half the price and twice the quality. That's the competition."

Virginia winemakers might also feel that the only reason the state has yet to break away from the pack and grab the world's attention as, for example, New Zealand has done is because "people don't know we are here for example or we haven't got the right conduit to bring these people to the winery." He says that we need to continue to improve quality and keep getting the word out by participating in international wine shows such as the London Wine Expo, which a number of Virginia wineries recently attended; keep competing in out-of-state national and international wine competitions; and add to the agenda of the winemakers' roundtables to focus on comparative tastings of Virginia wines against others. He is also critical, as are a lot of winery people, of the change in the winery agritourism business from a focus on making fine wine to a focus on festivals, weddings and entertainment. Dr. Zoecklein knows that he is not a winery owner, knows that most wineries are cash flow–dependant businesses and knows that most wineries sell what they produce in part due to these events, but he stresses that the wineries "needs to come together" on these issues if their goal is to move to the next tier populated by Washington, Oregon and elsewhere.

Dr. Zoecklein says,

The state will continue to move ahead on the important price-to-quality ratio—however, price here is very difficult to reduce—and the state will improve. Every emerging wine region in the world that I visit is trying to move forward and generally are; it's just a matter of the pace. I frequently get the comment that Virginia wines have gotten better. It's a good thing that they have, because the market certainly has gotten more competitive. The point is as an aggregate it is equal to better or less than what's available at the marketplace, particularly the price-to-quality ratio? There are some nice wines crafted out there. There is something exciting happening out there.

Dr. Zoecklein offers more than just armchair criticism. He wears several hats at the Enology Service Laboratory, where he conducts research, oversees extension, teaches and acts as business manager. He struggles to get by, as his enology resources have been cut in half over the past ten years while the number of wineries in the state has almost doubled.

He says,

> *What I think I need is what I said to the university here for six years and that is more extension help. I have a three-way appointment: research, teaching, extension, plus business management of the lab service. It's not possible for me to go visit all these place or have a short course every two to three weeks. We need to have more than one person to be the functional equivalent of all these county agents we have.* [He is talking about the viticulture extension agents whose numbers have increased and whose focus is grape growing and not winemaking.] *My extension activities are currently web based.*

Dr. Zoecklein has resigned himself to the fact that no more funding will be coming from the school anytime soon, particularly as it looks for a new dean. One of his assistants is already paid from the Virginia Wine Board, which is funded in part from state tax receipts, thus cutting into the research budget. So he has come up with a clever idea of how to grow the school's enological reach. He has enlisted the aid of the school of business to develop a model for how the school could run a private, for-profit wine laboratory. They said it was possible, but the laboratory would need to accept wine from out-of-state customers in order to pay the cost of the equipment and staff. Today, the wine laboratory at Virginia Tech has two full-time chemists. The laboratory is kept busy based on Dr. Zoecklein's reputation and, of course, the fine equipment and chemists working there.

Dr. Zoecklein points out that even UC Davis does not offer laboratory services. He says, "We do chemical, physical microbiological and sensory analysis." By that, he means that he tests wines for stability and answers such practical questions as "should we sterile filter this wine?" or "how much nitrogen do we need to add to this juice to ferment the wine to dryness?" Further, each day, Dr. Zoecklein and his staff do sensory evaluations of wine—that is, they taste it. He is reluctant to heap praise on anyone offering the best wines; rather, he gives the assessment that "this wine contains no enological flaws."

BARREL OAK WINERY

Airplanes are built with backup systems for everything: two engines, two sets of hydraulic brake lines, extra fuel, extra radios. Disaster would ensue if any of the primary systems were to fail. That's what happened to the first vintage at Barrel Oak Winery in 2008 when the single wine press broke down as tons of grapes stood ready for processing.

Rick Tagg is one of the winemakers at Barrel Oak, along with Sharon Roeder, who with her husband Brian is owner of the winery. Recalling that day, Rick said that the wine press was making an odd noise. Brian said, "Something's wrong."

Sharon and Rick chanted in unison, "There's nothing wrong." Rick added, "When the pomace falls down it always makes a bang."

But inside the press, the gear that drove the rotating drum was slipping. At one point, there was so much stress on the housing from the tons of fruit inside that it sheared the motor off.

Rick says, "I will never forget this as long as I live. At eleven or twelve o'clock at night you here this 'ka-boom.' Then all the fluid from the motor drained on the floor just like it bled to death."

Brian rushed out to replace the broken-down press so they could finish processing seven thousand cases of wine in what originally had been planned as a ten-thousand-case winery—a portion of the wine they made was for Narmada and Delaplane Vineyards, which are new wineries that had not yet built their own facilities. The Barrel Oak business plan called for the original press to last a few years. Brian says, "It was serendipity that we broke our press. So we bought the [new] press that I wasn't going to buy for two more years."

From its hilltop vantage point, the vineyard at Barrel Oak Winery unfolds in a rolling carpet of trellis wire and dormant vines on a bitter day in January.

At six feet, five inches, dressed in a winter parka, vineyard consultant Chris Hill stands a full head above everyone else as he doles out instructions to two vineyard workers who will finish pruning this young vineyard, having spent the rest of the winter stringing miles of trellis wire. The top of the vineyard is planted with eight thousand vinifera vines, while the bottom is planted with seven thousand hybrid vines, and more are going in this spring. This site is ideal for growing grapes, for it sits high above the frost with a southern exposure to the sun and a breeze to dry the morning dew in the growing season. But just as important as agriculture, commerce is a consideration, as Interstate 66 is within eyesight. Terroir is important for a winery, but so is proximity to cash-paying tourists.

Inside the winery, Rick, Chris, Brian and Sharon gather around a table in the tasting room to talk about this year's wines. At the Northern Virginia Winemakers' Roundtable this year (see the chapter "The Winemakers' Roundtable"), Rick and Sharon brought a couple of their problem wines to solicit the opinions of the other winemakers in the group. Nature that year had handed the winery some complexity. Rick said, "The seyval came in and there was some sour rot. This will compromise the nitrogen nutrient needs in your juices." This is called YAN, yeast assimilable nitrogen. Many wine drinkers know that wine is made as yeast convert the sugar in grapes to alcohol and carbon dioxide. But they might not know that yeast need nitrogen as a nutrient. Rick says, "If you don't have enough YAN, the yeast will start to make volatile sulfur compounds." These are the off aromas like hydrogen sulfide. He says that when they first racked this wine, patrons upstairs were startled by this aroma and looked down in the cellar, saying, "What are you guys doing?"

This kind of complication is normal in a winery. Rick phoned up Justin Bogarty, the winemaker at Veramar Vineyard, who had also purchased some of this same seyval fruit. Justin had tested it and that test revealed that the fruit was low in nitrogen. So Rick called Matthieu Finot at King Family Vineyards to ask what to do. Matthieu said, "Feed it." So Rick added Fermaid K, which is a yeast nutrient additive made from yeast hulls and, of course, nitrogen.

The winemakers at the roundtable told Sharon and Rick to add copper sulfate to the wine. This converts the hydrogen sulfides in the wine to the solid copper sulfide that sinks to the bottom, thus eliminating the problem. (You can reproduce the same results by dropping a penny into a glass of foul-smelling wine.) To get rid of the copper, Rick says they will do a yeast hull fining. "Fining" means that you add something to the wine that has the opposite electrical charge of what you are trying to strip out. For example, you add proteins that have a positive electrical charge to wine to attract the

negatively charged particles floating there to clarify the wine—that is, to make it sparkling clear. But with a yeast fining, the copper and the off aroma sinks to the bottom and you rack the wine and the problem is solved.

Sharon's wine is the stainless steel fermented chardonnay. Demure and slight, Sharon is not as talkative as Rick, so Rick speaks up, explaining that the fruit was bought from Breaux Vineyards. The 2008 vintage was cool, rainy weather in the spring and drought in August, followed by torrents of rain in September. Sharon blocked the wine from going through malolactic fermentation to make a crisp wine. Sharon's husband Brian is the businessman here. He said this wine will become the reserve chardonnay because they already have a barrel chardonnay and it is not sold as a reserve wine. Rick says this wine has the distinction of being the first grapes pressed at Barrel Oak Winery.

As businessman and spokesman, Brian is the talkative member of the Roeder family. He says,

> We opened our doors with a stainless reserve. Sharon wanted to do a stainless steel chardonnay. Nothing else made sense. Seyval blanc did not seem adequate for a reserve. We spend more time with the wine but it's also marketing. Some people come in [to the tasting room] and say, "I just want to try your reserve." Our goal is to make all of our products at high quality. So we decided to identify a reserve line right off the bat.

Asked why he planted his vineyard with so many hybrid grapes, Brian says,

> The hybrids were based upon location. It is our lowest and most vigorous soil. Those hybrids will do better there. We know this because we did a full soils analysis and a topo flyover mapping the land and altitudes. All of our higher fields are less vigorous and less frost prone and are therefore planted with vinifera.
>
> As for sales, the hybrids will be major components in our house blend wines. They also make good color and flavor additions to the vinifera if they come up a bit short in the future. Each is a distinct and pronounced blender. At the same time, our customers do not seem to feel that hybrid labels such as our seyval blanc or chambourcin port are less worthy of purchase. Quite the opposite, they are outstanding and distinctive wines and our patrons really seek them out.

THE ENTREPRENEUR

CHRIS PEARMUND

Workmen noisily pound nails and saw boards at the new Vint Hill Craft Winery in Northern Virginia, located in an office park at an abandoned military base in the outermost suburbs of Washington, D.C. Chris Pearmund, wearing a golf shift, khaki shorts and pastel-colored boat shoes, attends to every detail of the construction, from picking among different variants of Italian tile and ordering the winemaking equipment to personally working with the electricians to run wiring to a junction box. Chris is known to area wine enthusiasts as the winemaker and managing partner at the winery that bears his name: Pearmund Cellars. While his winemaking skills are notable, perhaps his greatest ability is as an entrepreneur, having assembled a handful of wineries. He calls Vint Hill his "lucky number thirteen." He has written business plans, crushed grapes and consulted for, invested in and found financing for a number of ventures, including two wineries in North Carolina, a shopping center in Warrenton, the Winery at LaGrange and, of course, Pearmund Cellars, which are partnerships, of which Chris is the principal partner. Working six days a week, Chris is unable to sit still as he talks on the cell phone arranging every last nail and nuance in what he says is a brand-new idea: a commercial winery where the customer is the winemaker. He gushes, "This is a new concept: for people to be participatory."

Virginia has a handful of commercial wineries, including portions of the farm wineries Horton, Prince Michel and Williamsburg and all of Quatro Goonbahs. What makes these commercial wineries different from farm wineries is that they are not bound by the rules that say they are limited to using Virginia-grown grapes, 51 percent of which the winery has grown on its own properties or on leased land. A commercial winery can source grapes from anywhere, including the biggest grape market of them all: California.

The Entrepreneur: Chris Pearmund

So it is with Vint Hill Craft Winery, where the keyword is "craft." Envisioning a franchise operation of wineries built in urban settings, Chris says the customer here is the winemaker. For $6,000 per barrel—which is twenty-five cases of wine—the customer can be personally involved in the making of wine, which can be a Virginia viognier or a California zinfandel. Soon grapes will be brought in from Washington, Oregon and even overseas.

Having repeated his sales pitch a hundred times, Chris's description of his operation rolls out in rapid-fire cadence: "Our customers are restaurants and stores. Our customers are individuals and groups of people who want to come here and make a wine barrel."

Lots of local wineries produce wine for others either under the custom-crush model—where the customer is usually another winery—or private labeling, where, for example, a restaurant can have its name written on a wine bottle. Senator Mark Warner does that with the grapes he grows at his Rappahannock Bend Vineyards. But the idea at Vint Hill is that restaurant and wine shop "staff will come here and learn about wine production. Have their products labeled and participate in making the wine. The staff become more valuable." Chris has already signed up the restaurants One Block West in Winchester and Iron Bridge in Warrenton and the wine shop Cork and Fork, which has locations in Bethesda and Gainesville.

Vint Hill has signed contracts with California growers who will hand pick, refrigerate and then ship east California zinfandel. Of course, he will use Virginia fruit as well. The idea is that the customer can choose the barrel, the type of yeast, the fruit and designate whether he wants a long maceration to exact more seed tannins in a specially built hothouse. "This is after fermentation. This is how they make the $100, $200, $300 wine in California. If you want more skin tannins, we can put it in a cold soaking room."

The wines here will be priced at twenty dollars, with some varieties, like viognier, costing more because that fruit costs more, or those treated in the hothouse because of energy costs. That price is not bad if you consider that the grapes will be processed using a double sorting table. The double sorting table is a labor-intensive step that is used to make premium, costly wines. The first step is to pick out any unripe or rotten fruit, what is known as MOG (material other than grapes), which are stems, leaves, whatever. The second step is to remove jacks, what the viticulturists call "racchi," which are the stems left when you remove the fruit from the cluster. If left in, these can make a wine more astringent.

Vint Hill has computers and software to design custom labels for each customer and an in-house bottling line and label printer. Twenty-five cases is a lot of wine for one individual to drink, so as a customer of the winery,

you can swap a portion of your barrel with wine from other customers or the winery will sell your wine in the tasting room here. Chris says, "We help you design the label. We print the label. We will facilitate getting the wine to your restaurant. Every barrel will be bottled separately."

Most wineries make wine using both stainless steel tanks and barrels, with a portion of the white wine and red wine made in the tanks. But Vint Hill will use only oak barrels for its white and red wine production, and for red wine production it has purchased a gentle hydraulic basket press. The customer can chose among the type and age of the barrel and pick the yeast and processing style. Chris says, "We have new oak, one-year-old and two-year-old oak from France, Virginia, Missouri and Hungary."

Asked how many customers want to be involved in the process versus having the winery do it all for them, Chris says, "Most customers want to be involved." Several winemakers will be on staff, with Chris overseeing everyone. "If you want to make a barrel of wine here we call you a 'vintner.' The second year you get elevated to 'winemaker.'" So that the starry-eyed aspiring customer does not get into trouble, Chris adds, "We're not going to allow anyone to make bad wine. We are not going to allow anyone to work alone."

Several winery owners interviewed for this book have repeated the same theme, which is that the days of ostentatious consumption are behind us. People no longer want to flaunt their wealth buying Rolexes and so forth—assuming they have any—but are looking for pleasure in more meaningful pursuits like making wine. Of the experience, Chris says, "Rather than go to a winery, rather than go to a liquor store to buy wine, people would like to own a winery without all the stress. This is a level in between. People will be fulfilling their passion, obtaining a higher level of education of winemaking and appreciation, learning all the tricks of the trade of a commercial winemaker and keeping their day job, while teaching you answers to questions you didn't know existed."

Always looking at the new money-making idea, Chris is already planning another craft winery in Washington, D.C., and wants to franchise his operation to Baltimore, Philadelphia and beyond, saying, "Let's say you want to own a craft winery. We will set you up with a layout design, trained winemaker, equipment and supplies sourcing, from business plan to website and marketing. We will also train you and your staff at an existing craft winery. In this economic downturn, people are less desirous to show their money and wealth. We could also help you get the funding and other investors as well."

Interview concluded, Chris hops into his Aston Martin and zips off to attend to other winery business, talking on his cell phone as he dashes off, no doubt thinking ahead to his next business project.

CUSTOM CRUSH AT MICHAEL SHAPS WINES

In the brilliant sunshine, Chris Hill, vineyard consultant; Jim Turpin, general manager; and Susan Prokop, owner; are blending wines for their new winery, called Democracy Vineyards. Jim is a political operative, having worked for the Republican Party before switching over to the Democratic Party, where he served as one of several Virginia state chairmen for Bill Clinton's election campaign. Michael Shaps, the winemaker, has lined up six bottles of traminette, chardonnay and seyval blanc, which will all be blended together to make the blend to be called Declaration, while their red blend will be called Velvet Revolution.

Inside, Gregory Rosko is dismantling tables and chairs where he and Michael have concluded a class for some thirty students from the Piedmont Virginia Community College on the practice of blending wine. Many of the students, like Jim, are people who have vineyards or plans to build a winery, such as Micah McDermott, who is currently working as an assistant winemaker at Barren Ridge. He will be leaving that job shortly to start a winery with his mother in Rockingham County in the Shenandoah Valley. Michael prefers to busy himself with arranging his winery rather than engaging in idle chitchat with his clients. He is not overly friendly to anyone but does make a good speaker, and he has a face that makes a good photograph; oddly enough, he looks like a French vigneron although he hails from New York State.

Greg's students are in a continuous education program, but one of them, a skinny blonde named Adrian, who describes herself as a musician, is enrolled in the degreed viticultural program. The group is divided into four teams, each of which has eight bottles of wine laid out before them. The goal is to make a blend from the merlot, cabernet franc, viognier, malbec

and petit verdot wines and then do a blind tasting to see which team has made the best wine. The teams carefully taste each wine and then note its characteristics on paper. Team number one observes that the petit verdot in new oak barrels has not completed malolactic fermentation and is put to the side because ML fermentation produces an awful smell. Then it decides for its formula to blend 400 milliliters of merlot—with supple tannins and a lingering finish—with 150 milliliters of a somewhat harsh cabernet franc to give the wine some tannic structure. Then they add 75 milliliters of petit verdot to give the wine depth and a dark color. Adrian is wayward with her thoughts. She asks the group to make two wines, wine A and wine B, rather than just one wine. To wine B, she adds a smattering of this and a bit of that while the scribe attempts to keep up with his notes. She then urges the group to add some viognier after the final blend is agreed upon. Then she loses patience altogether with the group and combines wines A and B together; the result is a mélange of grapes like a Châteauneuf du Pape. Team number three wins the competition, having decided to make a blend whose major component is petit verdot.

Water stains etch the walls of the Virginia Wine Works in Albemarle County, adding character to its rugged face of weathered winemaking. Under the previous owner, water seeped into the underground wine cellar before a new French drain was installed. This winery formerly was the location of Horton Vineyards for a very brief time before that burgeoning winery outgrew the facility and moved to its location in Orange County. The owners here are Philip Stafford and Michael Shaps, who also works as the winemaker.

The theme of the Virginia Wine Works is to make wine for others—this is called "custom crush"—and to make thirty-five-dollar wines under the Michael Shaps label and less expensive wines with the label Virginia Wine Works. Although it has been around in New York State and California for some time, custom crush is new to Virginia in 2006, having been made legal only in 2007. Basically, "custom crush" means that one winery makes wine for another. It is used to jump-start a winery's operation before a new winery has built a wine cellar, bought tanks and filters and obtained licenses.

Michael Shaps is a veteran winemaker in Virginia, having made wine here for about fourteen years. He studied winemaking in Burgundy at the Lycée Viticole de Beaune and has opened a one-thousand-case winery there, Shaps et Roucher-Sarrazin, with a partner in the Mersault appellation. After studying enology in Burgundy, he stayed in France for two seasons before coming to Virginia, where he worked at Jefferson Vineyards. Then he went to King Family Vineyards, where David and Ellen King financed the creation of the Michael Shaps label. Now Michael is here at the Virginia Wine Works.

Custom Crush at Michael Shaps Wines

Today's theme is blending wines, of which Mike says, "Today we are going to have some fun with blending. Blending is more of an artistic expression of the winemaker and place." With blending we are "trying to create something which is lacking in the wine, like depth."

In Burgundy, of course, there is no blending, as the vineyards in the appellations there are planted with chardonnay and pinot noir and nothing else. They don't even write on the label what grape is in the bottle—that New World practice is called "varietal labeling"—instead printing the name "Burgundy." But there is no need to blend wines there to make them stand apart from the others. Michael says, "In Burgundy you can taste ten different chardonnays grown a mile apart and they are all distinct."

The personality of the winemaker is written in the bottle, at least in the boutique wineries such as we have in Virginia. Michael says, "The wine really represents the personality of the winemaker." Michael tells the story of two winemakers in Burgundy who worked in wineries across the street from one another. Both drove different styles of cars. Both had different personalities. Neither had acknowledged the other, ever, even though they worked side by side. Both of them made wines from the same exact grapes. Yet their wines tasted nothing alike. One fellow was timid and shy. The other was outgoing, gregarious and opinionated. One fellow launched into his winemaking with flair and emotion, while the other made wine by the book. Perhaps boring winemakers make boring wine.

Michael today is talking about the different grapes that are grown in Virginia. As he pours a couple of bottles of his wines from Burgundy, it is a sobering reminder that certain grapes should be grown in certain places and nowhere else. His twenty-dollar chardonnay tastes of lemon and mineral. This is a flavor quite different from those California chardonnays that taste of mango and tropical fruits or Virginia chardonnays that, while Michael says they are quite good, taste rather neutral. Michael's eighty-dollar Burgundy pinot noir tastes exactly like cherries and is somewhat darker than the light color one would expect from this grape. Try as one might, this grape cannot from year to year make the same wine in the heat and humidity of Virginia.

Of Virginia's viognier, Michael says,

Chardonnay and viognier are a perfect match for each other. Some people use chardonnay to tone down the richness and intenseness of the viognier or you can go the other way around. Chardonnay tends to be a bit neutral in Virginia. It does not hold its acidity in all the heat and humidity, coming in at higher pH levels than in other regions of the world. Probably the most popular blend in Virginia is the chardonnay viognier blend. It works great.

The label of the Virginia Wine Works includes a drawing of two factory workers taken from a Soviet propaganda poster. The theme of that label is lower prices for the masses. One way to bring down the price of wines is to add hybrid grapes like vidal or even the American grape norton, for these grapes are sold at lower prices than vinifera in Virginia. Michael says of his use of vidal blanc with viognier, "With vidal blanc the objective is to make a lower-priced wine." He points out that in the United States, in order to be a varietal bottling, a grape needs to be 75 percent of what is in the bottle (in Europe it is 85 percent), so the winemaker has 25 percent that he can use to add something else to achieve the desired goal of lower price or to add some flavor, color or texture that is lacking.

Blending grapes can be used to help make a good wine in a bad year. He mentions cinnamon-tasting petit manseng, the aromatic grape of the Jurançon region of France, saying, "Viognier is becoming popular to blend with petit manseng. It doesn't take much petit manseng to blend with anything to be noticed." He says if the grape is not ripe, you can add some petit manseng so that "we have consistency whether we have hurricanes or not."

Some grapes are not recommended for Virginia, in particular, gewürztraminer, sauvignon blanc and riesling. But he adds, "If you find the right site in a good year it does good." Of course, the corollary to that is that in a bad year it does, well, badly.

As for hybrid grapes, Michael says, "For white wines vidal and seyval are great blenders. Seyval comes in very early but falls apart if you don't get it [in time]. As a grower, I would stay away from hybrids because it costs the same to grow them but you are not going to get the same return." He points out that the hybrid traminette is better suited for Virginia than its vinifera parent gewürztraminer. And "some people do not grow vinifera because they don't have a site that will allow it."

As for the red hybrid chambourcin, Michael says, "Chambourcin is a great blender. It used to be a workhouse in the Virginia industry to provide color and lift." Chambourcin also gets good color even in bad weather. He calls it a "low tannin, inky, dark wine," saying for the growers in the blending class, "Chambourcin is the only red I would recommend."

He says Virginia can make a nice sangiovese but it will never compare with Tuscany. For that reason, it should not be planted here because a wine "should be able to hold its own against the best international variety at that same price." Of Virginia Bordeaux blends, he says, "For me, our Bordeaux varieties are consistent on an international scale."

Of malbec, he says, "Malbec in Virginia does not do well in cold winters and cold sites." He says that it holds up in rainy weather. Even coming in at

a low nineteen Brix, "you can get great color and great flavor. [It is] easy to work with if you can get it through the winter and through the rain."

As for cabernet sauvignon, his opinion has changed because of the availability of early-ripening clones. He says, "Later-ripening clones need more growing season to mature. Four or five years ago I would have said don't plant cabernet sauvignon in Virginia."

He says, "Structure and tannin are the main aspects of cabernet sauvignon. [You] get dusty tannins when [it is] done right." But when it is not ripe, it can be "vegetal hard and aggressive. This is where blending comes in, to temper the grape."

Of merlot, he says, "Merlot is a grape, especially in Virginia, that is consistent. [It is an] early ripener, three to four weeks earlier than cabernet sauvignon. As long as you can get it through the rain and moisture, you can leave it there to hang, but with cabernet sauvignon you are running out of degree days. I believe merlot in Virginia is underrated for what it can do."

Of cabernet franc, he says,

Cabernet franc is very flexible in terms of production styles. Cabernet franc holds up really well for the grower. It does not fall apart in the rain. There are some really bad cabernet francs. [It is] really hard to get ripe. If overcropped it can be really terrible thin and vegetable. That's old school Virginia and they are still out there today we are still making it [that way]. [But] people are learning better canopy management. Winemakers in California know about Virginia cab franc. It has become Virginia's unofficial red grape.

Finally, he talks about another Bordeaux grape grown in Virginia: petit verdot.

Petit verdot is the direction the industry is going as a mainstay in the industry. It can fall apart in heavy rain. You have to be careful not to push it, depending on how ripe it is. If you pick it early you do not get so much green flavor but what you do get is color. In certain cases it can be a big, tannic wine. In addition, it ripens very easily with high sugars. It also maintains its acidity, whereas a lot of varieties, like cab franc and merlot, will lose their acidity and need to be adjusted. It's a great grape. Everyone is now rushing to make a varietal petit verdot.

He wraps up the blending class by saying, "If you think about Bordeaux, they usually have a house style. Vintage to vintage, they adjust." He means that winemakers the world over add sugar, tannins and enzymes. But vintage variation is what makes Virginia wines interesting, he says:

I don't think I had made the same exact blend two years in a row in Virginia. One year in Virginia one variety might be better than another variety. Consumers get confused because they like the blend and it's changed the next year. This I like about East Coast [winemaking]. *The West Coast, for me, it's more like Campbell soup—the same every year. This is why I am here and not in California.*

Sacre bleu.

THE AFRIKANER AT
KESWICK VINEYARDS

Stephen Barnard grew up and developed his winemaking and grape-growing skills in the pinotage vineyards of South Africa, a variety that he says he doesn't like much. He came to a Virginia vineyard, 1/3 of which is norton, which he says he does not like at all. His future father-in-law chose this American variety, believing that cabernet sauvignon and other red French grapes would not ripen in the Virginia weather. But Al Schornberg has changed his mind, especially after Stephen brought home the Virginia Governor's Cup made from a Bordeaux variety grown right here at Keswick.

This four-hundred-acre farm enjoys proximity to the namesake Keswick Hall, although the two properties are in no way related. With forty-five acres of grapes planted and only two full-time employees in the vineyard, Stephen spends his days mainly outdoors in the heat, humidity and bitter cold of Virginia. Contrast that with his native South Africa, where pruning is done in winter weather, which is like an Easter Day in Virginia. Stephen, whose mother is an Afrikaner and father a South African of British descent, has sort of an Arnold Schwarzenegger story. This handsome foreigner with European features and an Afrikaner accent came to America and will soon marry into one of the wealthy families here. You might expect him to gloat, as does the governor himself, "I married a Kennedy!"

A book on Virginia wines must make a stop at Keswick Vineyards because Stephen's renown as a grape grower and winemaker is well known in the industry. Talking a bit too quickly, with the impatience that is youth, this African expatriate has not yet absorbed the suggestion of his notoriety. He shies away from the suggestion that he step up and assume leadership of the Virginia Wineries Association, whose leader's tenure will shortly come

to an end. If he cannot yet believe that he has earned such a position in the leadership of the Virginia wine industry, the string of medals he has left behind speaks for itself.

Lots of local newspapers in Virginia simply print the press releases sent from area wineries without understanding what they read. For example, to say that a wine has won a silver medal in a wine competition means not much, especially when it is a provincial competition where one's wines are not pitted against wines from abroad or other states. But Keswick and Rappahannock Cellars, where he worked in 2004 and 2005, have brought home the Olympic Gold medal equivalent several times under Stephen's stewardship. The Keswick 2007 viognier earned a double gold medal at the San Francisco wine show. That is noteworthy. And the Keswick Vineyards 2002 Viognier Reserve won best of show white wine at the Atlanta Wine Summit. He also won the Virginia Governor's Cup with the 2005 Rappahannock Cellars Viognier Reserve from fruit grown at Keswick.

Stephen's future father-in-law likes an aesthetically pleasing vineyard where all of the vines are meticulously clipped and trained onto a VSP (vertical shoot positioning) system. This, of course, looks quite orderly, but Stephen says it ignores the conditions of the soil in which the grapes are grown. At the entrance to Keswick Vineyard, norton grapevines stand in a water-soaked swale whose vines Stephen wants to rip out. The vines are grown here on Albemarle clay soil that is overly vigorous. The viognier and Bordeaux red varieties grown behind the winery are on a manteo tatum mason soil, which consultant Chris Hill says is "rotten shale. You would not want to grow a garden there." So the vines in the back are grown on a VSP system, and those that are more vigorous are trained to Stephen's liking into a ballerina system, where half of the shoots are allowed to flop outside the trellis and hang down to give the vigorous vines some place to grow. Stephen says, "At first we were on VSP. That was aesthetically pleasing but now we're trying to grow better fruit. We get better ripeness. You get an open canopy, which minimizes disease pressure. You get better spray penetration. You can crop it slightly higher and still get better fruit."

Of the norton growing out front, Stephen says, "Norton. I hate it. Can't stand it. It's an interesting grape to work with. Norton is not for my palate, although it outsells my favorite wines in the tasting room. It sells almost two to one more than the traditional wines. Not sure why. It comes across a little sweeter, more acidic."

The really interesting wines, says Stephen, are the Bordeaux blends. The Governor's Cup cabernet sauvignon–merlot blend has a slight sweetness that indicates fully ripe fruit and cedar and cigar box notes of complexity. This tannin and fruit are ripe in a state where for years some growers

would not grow cabernet sauvignon, saying it would not mature. All of that changed when clone 337 was developed, a variety that ripens three weeks earlier than others. The cabernet sauvignon–merlot blend was bottled as a cabernet sauvignon varietal. Stephen says, "We felt the cab was so tannic but it lacked fruit and elegance and the merlot didn't. Wanted to see what that wine would do with another year's aging. We will bottle that under the Heritage label. We entered it in the Governor's Cup and it won. I was really surprised. I think this wine [the new Heritage blend] is better than what won." (The only difference between the two wines is that one is 20 percent merlot and the other 25 percent.) While he won the Virginia Governor's Cup, Stephen says, "I am disappointed that not all wineries and winemakers enter their wines, people like Jim Law who I regard as one of the best winemakers in Virginia."

Stephen says these wines have a "fair amount of smokiness, sort of spiceness on the nose. And a lot of black fruit. Very tannic. We get a lot of red fruit, strawberries and cherries and currants and a sort of plum." The Heritage wine is bottled unfined and unfiltered. Stephen says, "It will produce a lot of sediment." This is true, as sediment falls from the last glass you pour from the bottle. This is not a flaw. Quite the contrary, it shows a winemaker confident in his abilities, as others take the safer, more secure, route of sterile filtering the wine to sweep any possible bacteria that could spoil the wine. Robert Parker is highly critical of this widespread industry practice.

The two Keswick Bordeaux blend wines here are meant to be cellared and not drunk right away. For a fruit forward wine that is light on tannins, Keswick has touriga nacional, which other wineries, particularly those in Portugal, use mainly to make port.

Chris Hill says the problem with touriga nacional is that wineries do not understand how to handle this fruit. He says that unless you are growing it for yourself, you might as well not work with it. It does not produce much sugar in the Virginia weather and falls apart in the late season rains. Stephen says that they pick it at twenty or twenty-one Brix, which is not much when you consider that most grapes are picked at twenty-four Brix or higher.

Stephen says,

> *Touriga does not produce a lot of sugar. It comes in at twenty or twenty-one Brix. In Portugal, touriga is big but in our climate we don't get them ripe. It is much more fruit forward. We stick it in a barrel and bottle it in May. We don't use new oak. The flavor profiles should be redder fruit, a lot more cherry and raspberry and currant, softer tannins. We don't want it big and tannic.*

We do pre-ferment cold soak for two days. When it is done, we press it off.
With cab, we do a post-ferment maceration for a week or two but only if the
seeds are brown. In Virginia lot of people bleed on unripe fruit and accentuate
green bell pepper flavors. We punch down throughout the day and throughout
the night. We try to get a lot of extraction.

The barrels of wine here are carefully labeled as free run juice or press fraction. Grapes are pressed using a measurement called **BAR**, which comes from the metric system as a measurement of pounds per square inch. The barrels of chardonnay, cabernet franc and the rest are labeled 0.2, 0.4 and 0.6, which begs the obvious question of when the winery will blend it all back together to make the final wine. Stephen says, "It's all about learning. If we do it the same way every year we are never going to improve wine quality. It's all about experimentation."

Back at the winery, Stephen is chatting up customers with Kelly, who works in the tasting room. Stephen's fiancée, Kat, is working as a PhD microbiologist in a state that has no wine microbiology lab yet. Perhaps the young couple will be growing brettanomyces cultures together one day back in the cellar.

Stephen wraps up, saying, "I would like to add how excited I am to be in Virginia. I obviously want Keswick to be the best, but we are aware that we need to promote Virginia wines and have to work collectively to make sure that happens."

GROWING GRAPES WITH CHRIS HILL
AT POLLAK VINEYARDS

C hris Hill has an answer for the surfeit of sunlight in Virginia: it's called the "solar collector."

His client, Dave Pollak, and his wife Margo are the owners of Pollak Vineyards. As an executive at Cintas, Dave commutes to Virginia from Cincinnati, having commuted to Napa Valley from Delaware when he worked as an executive at Dupont. He is a veteran in the grape business, having made the first wines for Francisco Ford Coppola's winery at Dave Pollak's Bouchaine Winery, which he founded and then sold to the Dupont family. Changing venue to Virginia, Dave dispatched Chris Hill, a longtime grape grower and consultant who has worked at Jefferson Vineyards and elsewhere, with checkbook in hand to find and acquire a property for his new vineyard and winery.

Chris located a textbook perfect location near Rockfish Gap in Albemarle County between Veritas and King Family Vineyards, which are also clients of Chris Hill's. Dave says, "This was all an organic vegetable farm. I wanted it between 800 and 1,100 feet facing south or east." Pollak Vineyard made its first wines at Veritas Winery but soon overran the space there. "The very first year we made wine we put a refrigerated tractor trailer over at Veritas. We found out that Veritas couldn't take us the second year. We make 1,300 cases of reds there." Relocating to his own property to make wine, Dave brought on another Jefferson Vineyards alumni, Jake Bushing, who lives full time on the property as the resident winemaker, and the winemaker consultant Michael Shaps, yet another of the Jefferson wine-growing troika. Dave says he has permanent tasting room staff under Nick Dovel.

If you know about the early days of Napa Valley, you know that Coppola was one of the early wineries there, where "early" means the 1970s,

concurrent with the Judgment of Paris wine tasting. Dave says, "We were part of that generation that, not being pioneers, but sort of took it to the next level." He planted his vineyard and built his winery in Carneros, which is the southern end of the Napa Valley. "My winery was Bouchaine. That's my daughter's middle name." Dave bought the property from Beringer and planted thirty acres of grapes in 1978 and 1979. He says, "[It] had been an old pre-Prohibition winery. Had been not used except for large redwood vat storage. I bought it from them for $3,000 per acre. We were the first custom crush facility in Napa Valley." His winery grew to eighty thousand cases, making wine for Mondavi, Chimney Rock and others, and keeping "twenty thousand for ourselves."

As a busy executive living in Delaware at the time, and later in Europe, Dave commuted to California on the weekends and applied his energy to the planning and investment side of the business. He says, "A friend and I started as limited partners in groups that developed vineyards because it was a great tax shelter. We got a good consultant partner. [We] ended up owning acres along the Russian River Valley in Sonoma." The way they planted vineyards there was different than they do in Virginia. First he planted certified, disease-resistant native American rootstock in the ground, and the next year he field grafted vinifera wines on top. Virginia wineries buy such ready-made plants grafted and grown for a season in nurseries in New York and California. The other difference was that his Russian River Valley Vineyards had irrigation overhead and not underneath the trellis, as they do in Virginia, "because it always offered frost protection."

Circle back to Virginia, where various plots of grapes at Pollak Vineyards—Smuggler Field, Molly Gibson, Durant—are named for the silver mines that Dave's great-grandfather dug when he founded the town of Aspen, Colorado. Dave says, "My great-grandfather founded the town of Aspen. He bought the silver mines and laid out the town of Aspen. He made millions. He lost millions. The land is not on our side of the family anymore. One nugget out of the Molly Gibson weighed two thousand pounds."

Chris Hill towers above most people at six feet, four inches, and talks in the musical baritone of the Old South. When not standing in a vineyard, you could imagine him telling hunting stories like Havilah Babcock or Archibald Rutledge over a smoldering fire in some backwoods hunting camp. Chris is overflowing with personality and tells humorous tales with down-home humility. He fills his descriptions with anecdotes. Having worked for almost thirty years in Virginia's vineyards is beginning to wear on him, as phlebitis on occasion flares up in his legs when he sits still. So he sits still not long at all.

Growing Grapes with Chris Hill at Pollak Vineyards

Chris is better suited than the writer to relate his own history. He says,

I started in September of '81. When I first started Barboursville, the Zonins had come here. They were the first big operation. They had deep pockets and experience.

Everybody else was pretty small. When I got started we made horrendous mistakes. We put the wrong varieties in the wrong sites. We didn't spray properly. We had some severe cold weather in '85 we struggled through. Grapevines are fairly forgiving. We first had to learn to grow grapevines in Virginia with the hot tropical summers and the potentially bitter winters. In the end, you have to have a system. Within your farm you have to have a system for everything you are going to grow. One step leads to another. So when we started in this industry there were systems that came in from Europe and people who knew those systems and we had to make those systems work with our weather and with our soils. We would look and look for the best vineyard site and plant a vineyard. But people already owned land and "by god they wanted to grow some grapes." So we planted a lot of low sites for chardonnay. It didn't make any difference whether you had money or not. If you had money you just made a bigger mistake.

I had a couple of degrees in horticulture from Virginia Tech and I was looking to utilize those degrees and some of my newfound skills. By serendipity, I just had moved back to Albemarle County. So I had an opportunity. Even though I had studied horticulture I knew very little about grapes. The first year we planted nine acres and we babied those things. Good God. I was thirty years old. Another buddy was twenty-five and another twenty-six. We were fit and strapping young men. We did nine acres perfectly and we all decided in August we needed a vacation. We left. When I came back nine acres of the prettiest vines you had seen were 100 percent covered in powdery mildew. There wasn't a vine that escaped.

Now that Pollak is well underway, Chris spends his days at Democracy and other new vineyard properties. Returning to Pollak, he walks the vineyard and describes the system he has installed here.

Grapevines left to their own devices would grow into an impenetrable tangle of fruit and foliage through which neither sun nor agricultural spray could penetrate. In Virginia, ancient wild grapevines grow into treetops. Their weight is such that they threaten to bring down their hosts. In Europe, vines are trained to grow onto various trellises or no trellis at all. If you saw Brigitte Bardot in *And God Created Woman*, you saw her run barefoot and wild into a vineyard of head-trained vines. These are allowed to grow for five years or more until their trunks reach a girth that can hold their weight upright.

Here in the East, grape growers and researches such as the late Nelson Shaulis of Cornell and Dr. Richard Smart of Australia have developed different designs to hold the grapes aloft with maximum sunlight exposure so that they can ripen the fruit and not let it rot. Table and juice grape growers in New York State use Dr. Shaulis's invention, called the Geneva Double Curtain (GDC), named for the Geneva agriculture research station at Cornell. The GDC has two rows of foliage trained such that the shoots grow down. Growers of niagra and concord grapes designed for Welch's grape juice were paid by the amount of fruit they could grow and how much sugar the grapes accumulated. The GDC system proved best for this, plus it lent itself to some measure of automation. Rappahannock Cellars uses GDC to grow its norton grapes, as does Chrysalis Vineyards. The French, meanwhile, invented the French lyre system, which is popular among some Virginia growers while the French themselves no longer use it. The difference between the two trellises is that one grows the shoots in an upward direction and in the other they grow down. Horton Vineyards uses the French lyre, as do the older plantings at Linden Vineyards. One problem with it is that it requires lots of man hours to climb into the canopy and untangle the vines lest the two curtains of foliage grow into each other.

Most Virginia vineyards and the majority of those in Chile and California have adopted what is called the VSP (vertical shoot positioning) system, which is both easier to conceive and maintain. It is the simple design most people envision when they think of a trellis: all the grapes grow in a straight line in one row of shoots that are trained to go up. One of the advantages of the VSP is it is aesthetically pleasing and lends itself to automation: hedging, pruning and harvesting by machine. A closely clipped row of VSP-trained vines that roll across the landscape is easy on the eyes. But the VSP does not work in all cases, particularly in overly vigorous soils. Dr. Richard Smart, in particular, mocked the notion that only the French could grow great wine. He says that it is all about balance—there is an optimal ratio of fruit to foliage. If the vines are grown on deep soils that hold many nutrients and soaks up water, the canopy will explode from its confines—the grower will spend all his time and money trying to clip the vines back to civility. The vines need somewhere to grow beyond the confines of the trellis. Otherwise they will produce fruit that is not ripe and create wines that taste bitter and green. This is a problem that Chris Hill has pondered.

The observant viticulturist notices that, like Chris himself, the trellis at Pollak Vineyards is a little taller than usual, with the cordon wire hanging at forty-eight inches. Chris explains, "Dave Pollak was looking for a way to get a leg up [on quality]. This is very vigorous soil." Of growing conditions

in the East, he says, "We don't have any sunlight. Compared to the West Coast, our quality of light is awful. So you try and maximize the quantity of light you get. The whole purpose of doing the vineyard is to get light in the canopy."

His solution is one of Dr. Smart's inventions: the Smart Dyson ballerina. As on most vineyards, Chris starts off planting his vineyard on a VSP trellis. But if the soil proves to be too vigorous, Chris lets half of the shoots flop outside the canopy, where gravity points them downward. The resulting trellis looks something like a fountain or a ballerina in the midst of her pirouette. The goal is to give the overly vigorous plant somewhere to grow without crowding the canopy.

Poor soils are preferable for wine grape quality because they promote slow growth. The rich soils of the Midwest grow abundant amounts of corn, but grapevines would not do well in Iowa (although some growers try). In Virginia, even one small plot of land can feature several different types of soils only a few feet apart. One plot of cabernet franc at Pollak Vineyards is planted on a low vigor soil that Chris calls "droughty" and is harvested earlier than the rest. Chris says, "The whole idea of a poor soil is you end up getting sun into the depth of the canopy instead of getting this monster canopy."

Not all the vineyards enjoy the luxury of being able to plant their vines in a north–south direction, which is optimal. The reason for this is the sun rises and the early morning sun dries the dew from the vines. During the day, the grapes are exposed to the maximum amount of light and in a uniform fashion, especially as summer changes to fall. But if your vineyard is situated on a steep slope running north–south, then you cannot plant in that direction because your tractor and operator would tumble into the trellis as the operator attempts to navigate the slope while a heavy tank of water in the tractor's sprayer pushes the machine down the hill. Soil erosion is also worse if a vineyard runs in the same direction as the grade. Chris sums it up as, "You have a spray tank behind you, it starts pushing you and you're in trouble."

At the top of Pollak Vineyards, Chris points out a planting of petit verdot that is planted in an east–west direction because otherwise the vineyard rows would have been too short and soil erosion too high. He says, "North–south probably ripens fruit a little better, but I have a modified ballerina that works pretty well. What we do is one leg of the ballerina is down. One going up facing the sun. We leaf pull the other side completely. All of this fruit is wide open on the north side. It doesn't get a lot of direct sun, just the foliage." Pollak, Veritas and Keswick use this system in certain locations—the "solar collector." Chris says some people worry that the fruit from the downward canopy will ripen differently than the upward canopy. He says, "We have not

found that to be the case," adding that the grower still could elect to harvest the fruit separately if that is what he wanted.

As you drive across the Virginia countryside, a Chris Hill vineyard like the one at Pollak is readily identifiable in winter and early spring because of the way it is pruned. Most vineyards prune their vines to two or four buds and even leave more in the belief that the extra plant material hanging there will protect the dormant buds from winter damage. Chris says that if cold weather is going to damage the vine, it will damage the whole cordon and not just the tips of the dormant wood. Of the other growers, he says, "They feel like they are protecting their crop; I cannot blame them for that."

But the problem with having so many extra dormant buds is that the grape grower needs to return to the vineyard and cut them off again, which takes time and money. Plus, once they start growing, the resulting green growth needs to be untangled early in the season when the tender shoots are liable to snap off if they are handled. So it is best to prune the vines severely. Anyone who grows roses would understand that notion. Chris says, "What I would rather do is prune really hard and adjust the crop load. When you are doing shoot adjustment, everybody starts too late. You should be doing it now [May]. Everybody gets behind. You end up in June, you can't see anything. It goes really slow and it costs you a little money."

Interview concluded, Chris hops in his car and motors off to show someone how to operate their new sprayer. In Cincinnati, Dave Pollak, no doubt, is headed with Margo en route to the Charlottesville airport and the rental car counter.

ABOUT THE CONTRIBUTORS

Walker Elliott Rowe is a grape farmer, goat rancher and winery investor located in Rappahannock County. He has written three books on wine, including two on the wines of Virginia and one on the wineries and vineyards of Chile. Mr. Rowe is an MBA graduate of the George Washington University and holds a BS in mathematics from the University of South Carolina. He blogs on agriculture at www.rosewoodhillfarm.com.

Richard Leahy has been writing about Virginia wine since 1986 in a variety of media. He has been the East Coast editor and director of Eastern Programs for *Vineyard & Winery Management*, a leading wine trade publication, since 1999, and coordinates the seminar program for Wineries Unlimited, the largest trade show for the industry east of the Rockies. Mr. Leahy organized the Virginia Wine Experience in London, which brought the top sixty-four Virginia wines there for leading British wine media and trade to taste in May 2007. He was a regional editor for *Kevin Zraly's American Wine Guide* and was mid-Atlantic and southern editor for the *Oxford Companion to the Wines of North America*. He is a member of the Society of Wine Educators and the Circle of Wine Writers, and he lives in Charlottesville. Mr. Leahy has a website and blog focused on wines of Virginia and the East: www.richardleahy.com/blog.

Jonathan Timmes is a freelance photographer based in Metro Washington, D.C. Building upon his background as a painter and musician, Jonathan has developed an artistic and honest approach to storytelling through his photographs. He finds his inspiration in the creative risk-taking process and is driven by the educational exploration

of photography. His style has evolved over the years and is marked by his conceptual lighting techniques and dramatic, yet simple, use of color and composition. www.jonathantimmes.com

Visit us at
www.historypress.net